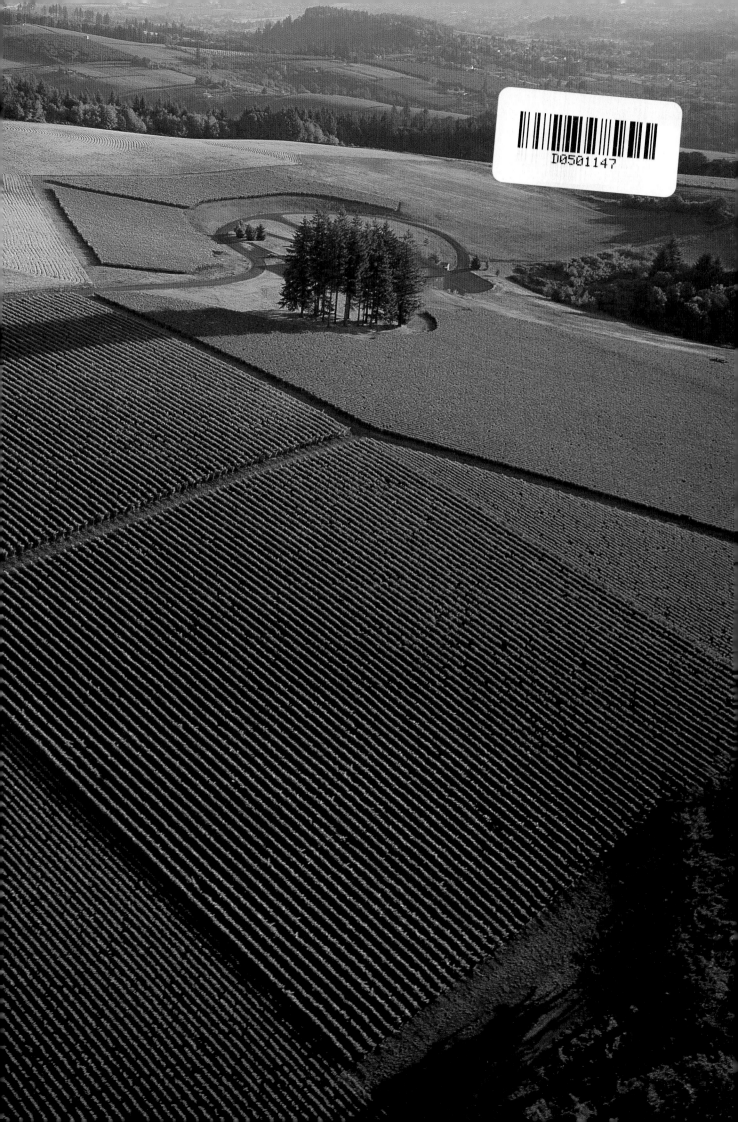

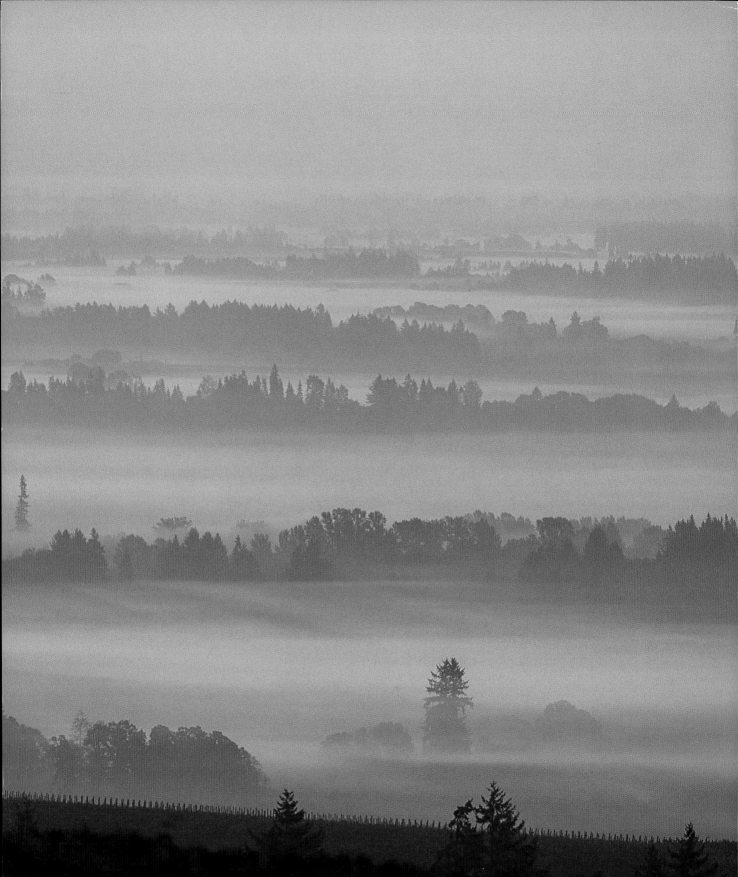

OREGON
WINE
COUNTRY

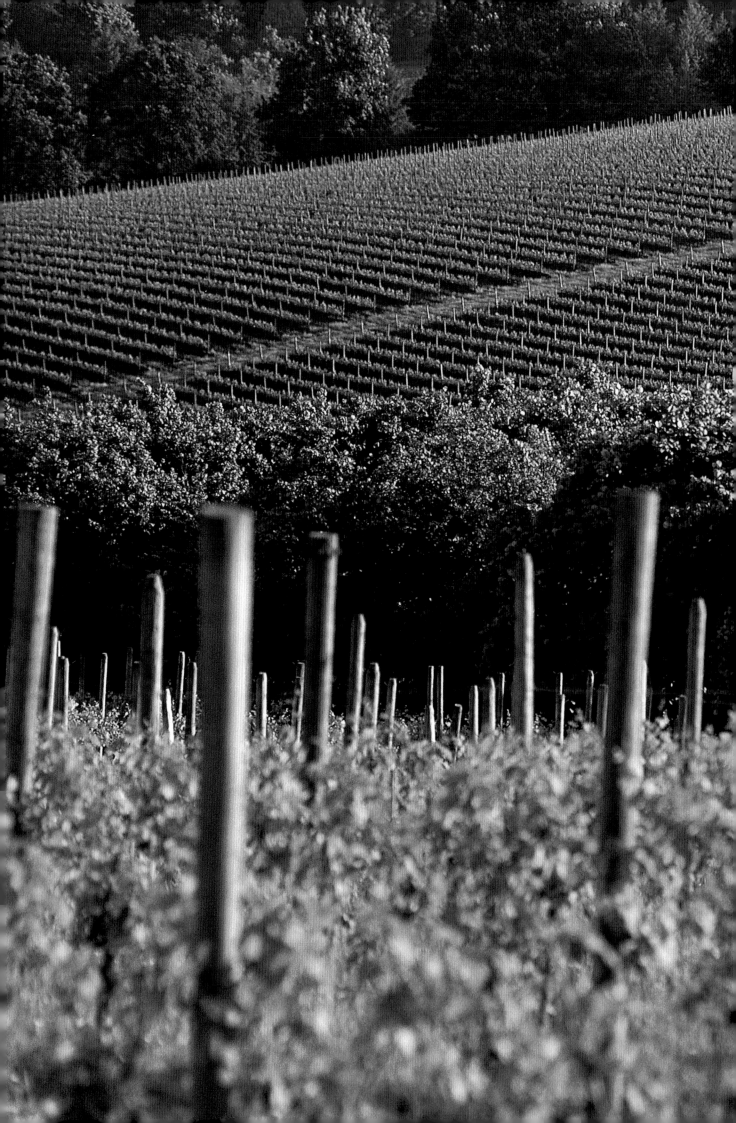

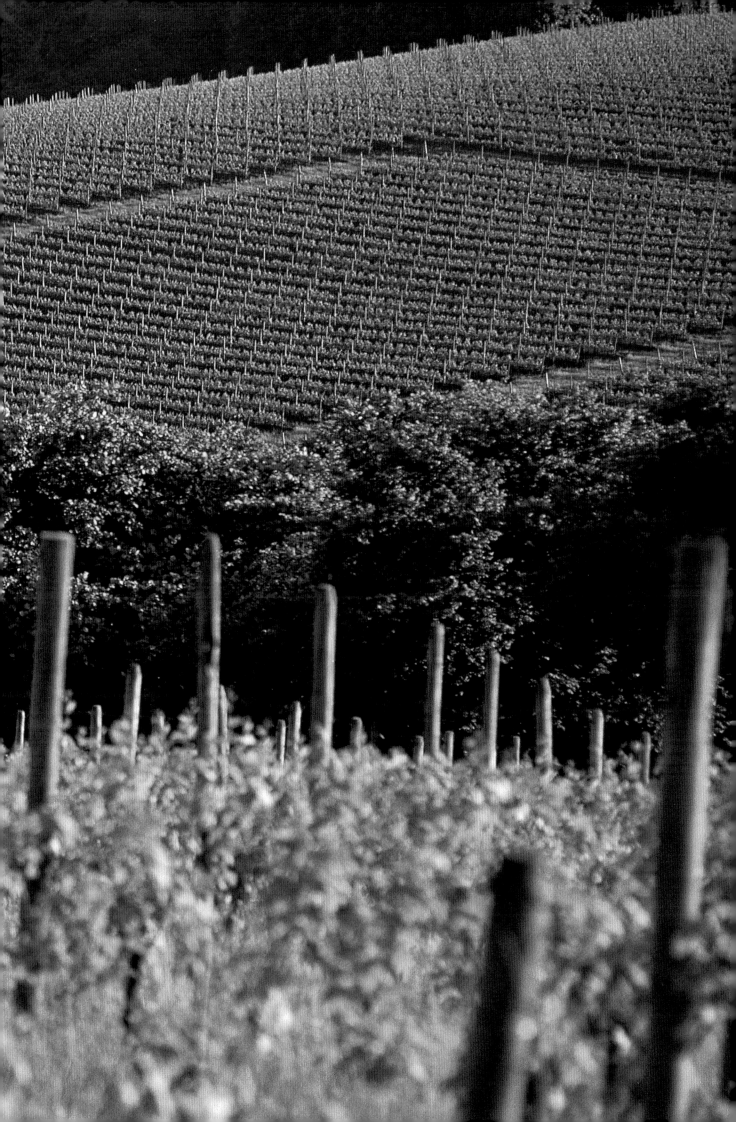

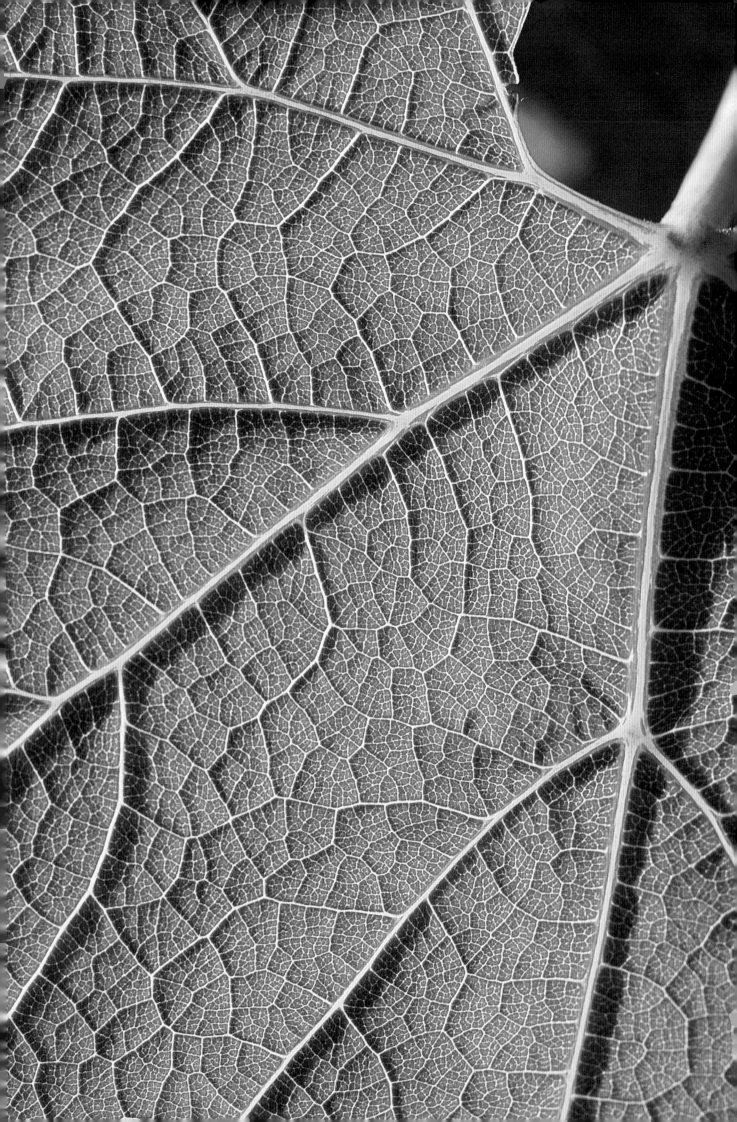

"The pinnacles of wine quality
always come from grapes grown
in marginal climates." —David Lett

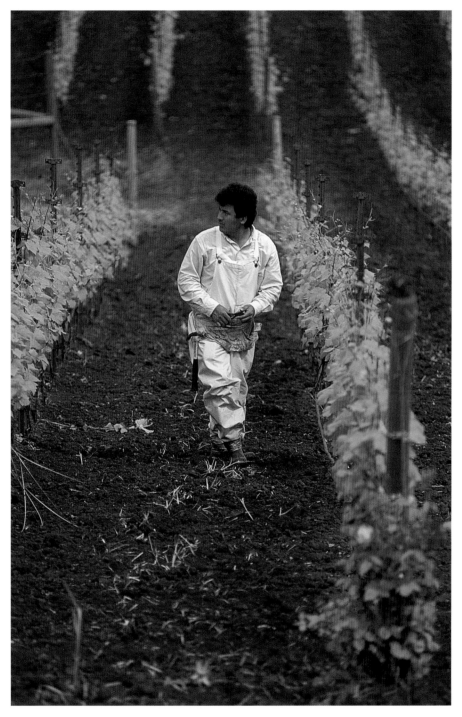

Pages 4 & 5: Sokol Blosser Winery's venerable Redland Vineyard, shown in late summer, nestles
on one of the northern Willamette Valley's prime south-facing hillsides. Languid summer evenings
provide the perfect venue for concerts in the vineyard—a tradition at Sokol Blosser in recent years.
The winery's grounds have hosted nationally acclaimed jazz, blues, and rock artists. *Left:* The vein
structure and shape of leaves vary with different varieties of winegrapes. *Above:* Many vineyards,
such as Archery Summit's shown here in mid-summer, employ full-time as well as seasonal workers.

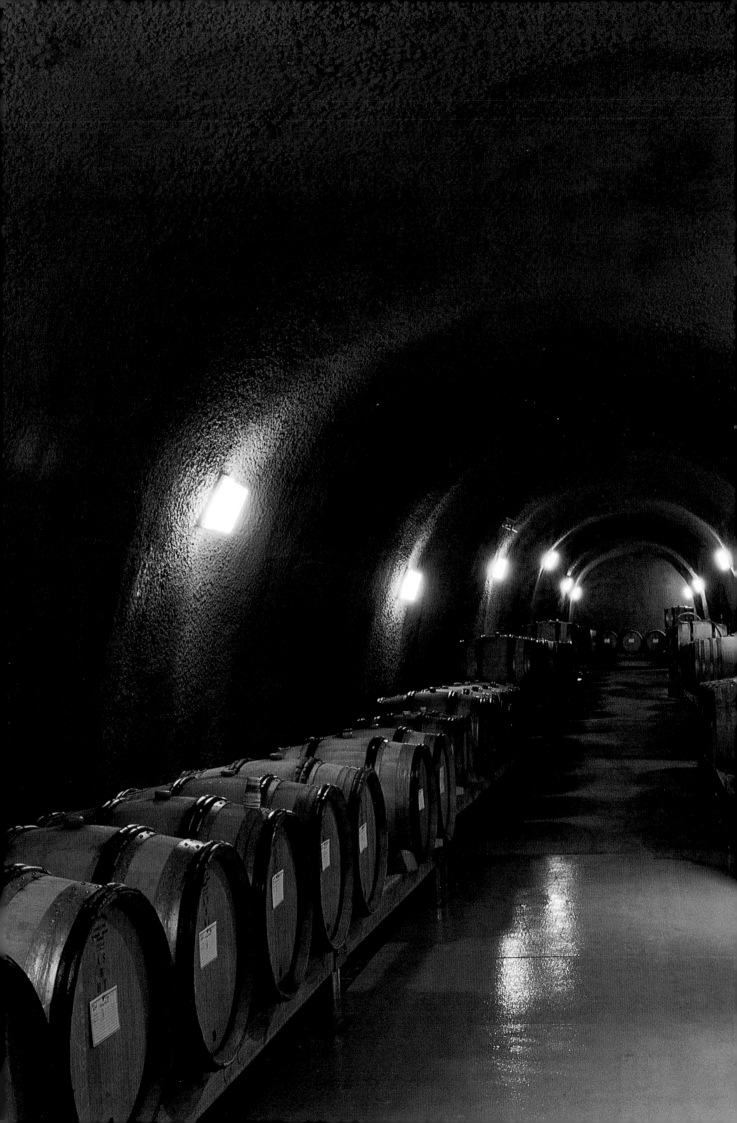

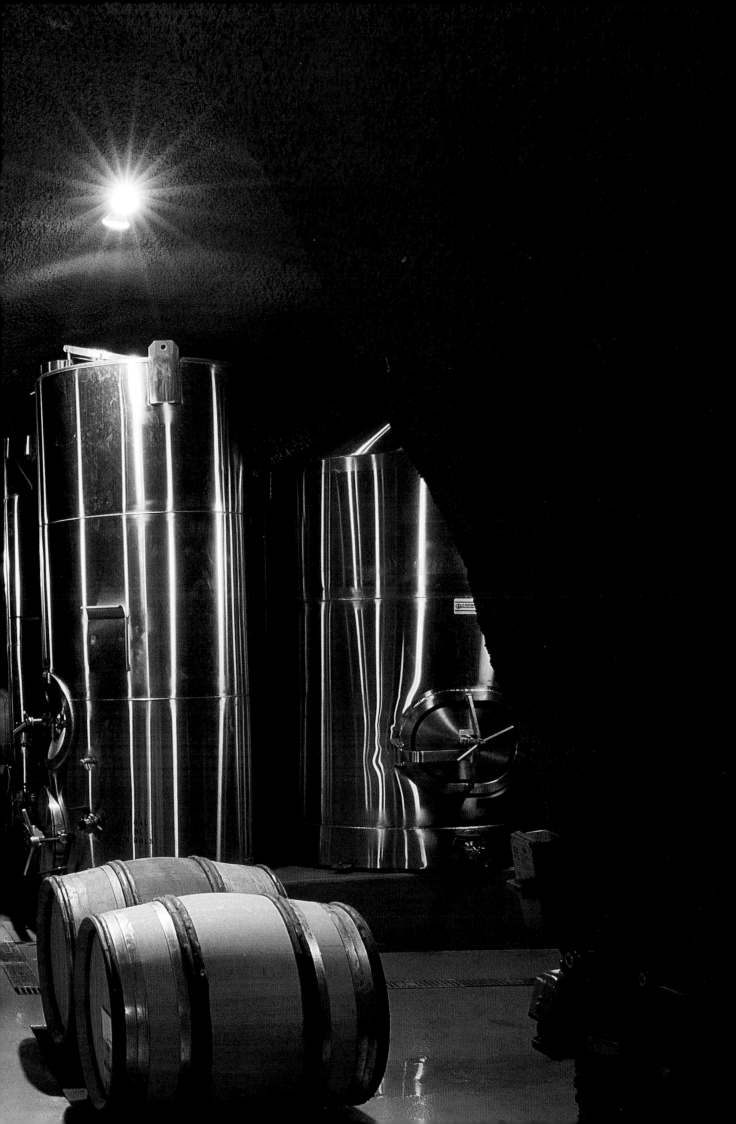

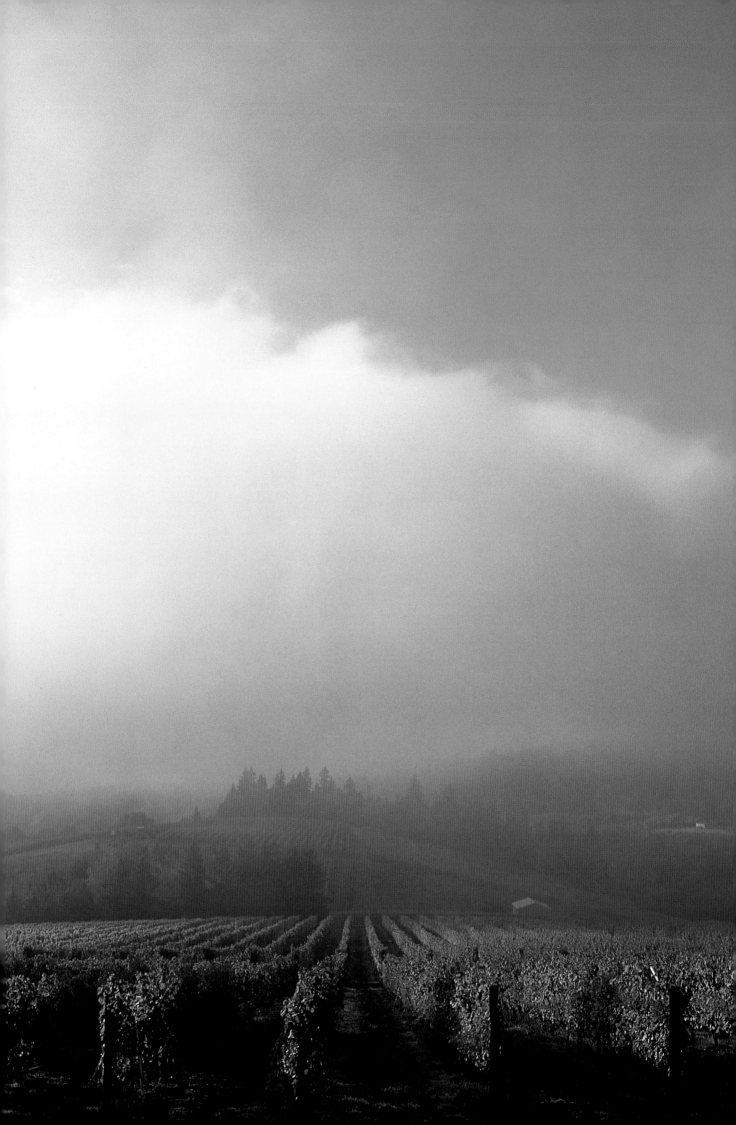

OREGON
WINE
COUNTRY

Photography Robert M. Reynolds
Text Judy Peterson-Nedry

Graphic Arts Center Publishing®

International Standard Book Number 1-55868-318-6

Library of Congress Catalog Card Number 97-80275

Photographs © MCMXCVIII by Robert M. Reynolds

Text © MCMXCVIII by Judy Peterson-Nedry

Watercolor illustrations by Wayne Chinn

Watercolor illustrations and compilation of photographs

 © MCMXCVIII by Graphic Arts Center Publishing Company

P.O. Box 10306, Portland, Oregon 97296-0306

503/226-2402

President Charles M. Hopkins

Associate Publisher Douglas A. Pfeiffer

Managing Editor Jean Andrews

Photo Editor Diana Eilers

Design Reynolds/Wulf Design, Inc.

 Robert M. Reynolds, Letha Gibbs Wulf

Typography Reynolds/Wulf Design, Inc.

Production Manager Richard L. Owsiany

Printed in the United States of America

Pages 8 & 9: Huge caves were laboriously drilled into the rock hill-sides of the Dundee Hills when Archery Summit Winery was built in 1995-96. The caves are now used for barrel aging, but also offer a setting for romantic winery dinners and other events. *Page 10:* Rain clouds play above vineyards, teasing vintners at harvest time in Oregon. *Opposite page:* Guests enjoy Oregon wines and dining *al fresco* at a private party in a small Oregon vineyard.

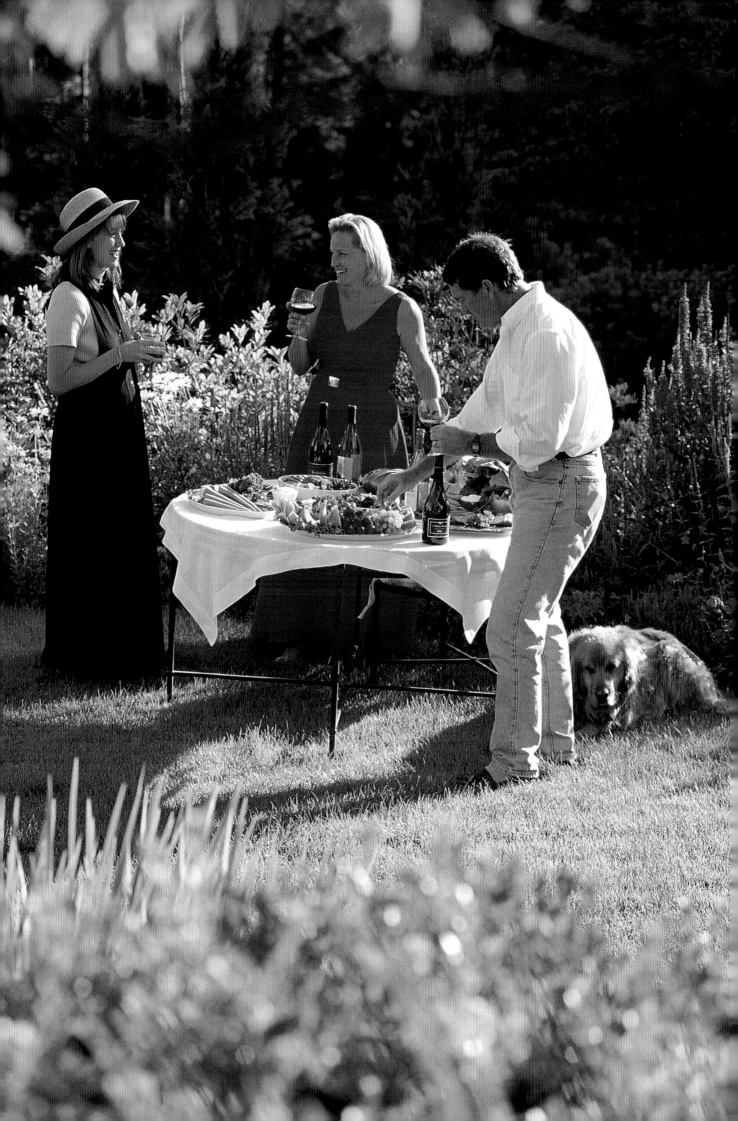

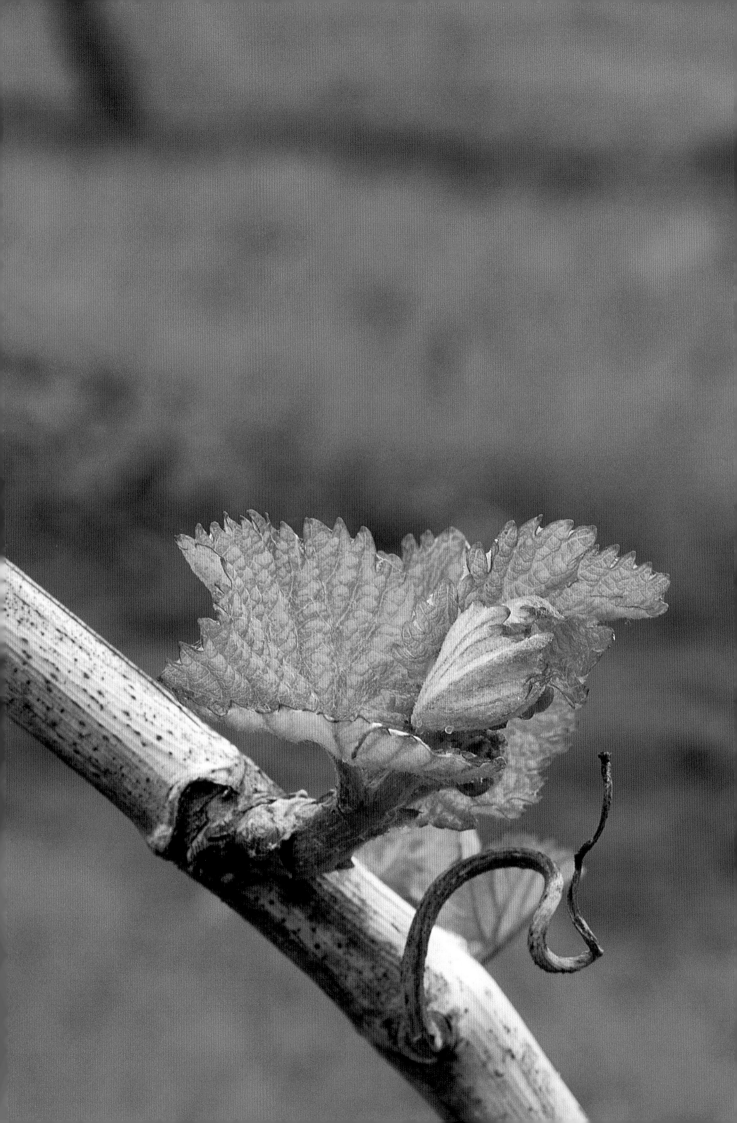

Come along in spring. There's a soft breeze blowing, curling over the Cascade Mountains from the Pacific Ocean and into western Oregon's temperate, protected valleys. Red clover carpets the valley floors in crimson, and on the hillsides grapevines send out their first tendrils— tentative, tender, the most incredible shade of yellow-green imaginable. Tiny, primordial grape clusters await bloom. Vintners throw open their doors to welcome the season's early tourists as they release the first wines of the previous vintage. Come along in summer. The vines are in full foliage now, a deep kelly green and reaching toward heaven. The bees are buzzing and the wind hums in the trellis wires. Rich, deep red soil lies between the vineyard rows. The sun will burn if one isn't careful. Inside, the winery is appealingly cool and dank, offering luscious aromas of wine and damp oak barrels. Visitors wipe their brows and sip a crisp Riesling or Pinot Gris, then listen to the old-timers tell of what it was once like in Oregon wine country. Come along in autumn. Clouds gather over the mountains, teasing the vintners, making them nervous with the occasional rainstorm. Crews are busy picking. The days start with foggy mornings, continue through languid, sunny afternoons, and end with a harvest moon. The yellow jackets are feisty; the smell of ripe grapes, intoxicating. Watch your step—forklifts are buzzing around; the winery floors are wet and slick with grape skins. Everyone is busy, but it is part of the process. Go with it. Come along in winter. There are wine tastings and wreath sales, a welcoming bonfire. Mulled cider is available for the children. Voices join in laughter. The harvest has been a good one. It is now time to celebrate. It is time to sample the new Pinot Noirs. Mmmmm. In the vineyard lie dark, dormant winter vines awaiting rebirth, frosty soil, and a dust of snow. Come along.

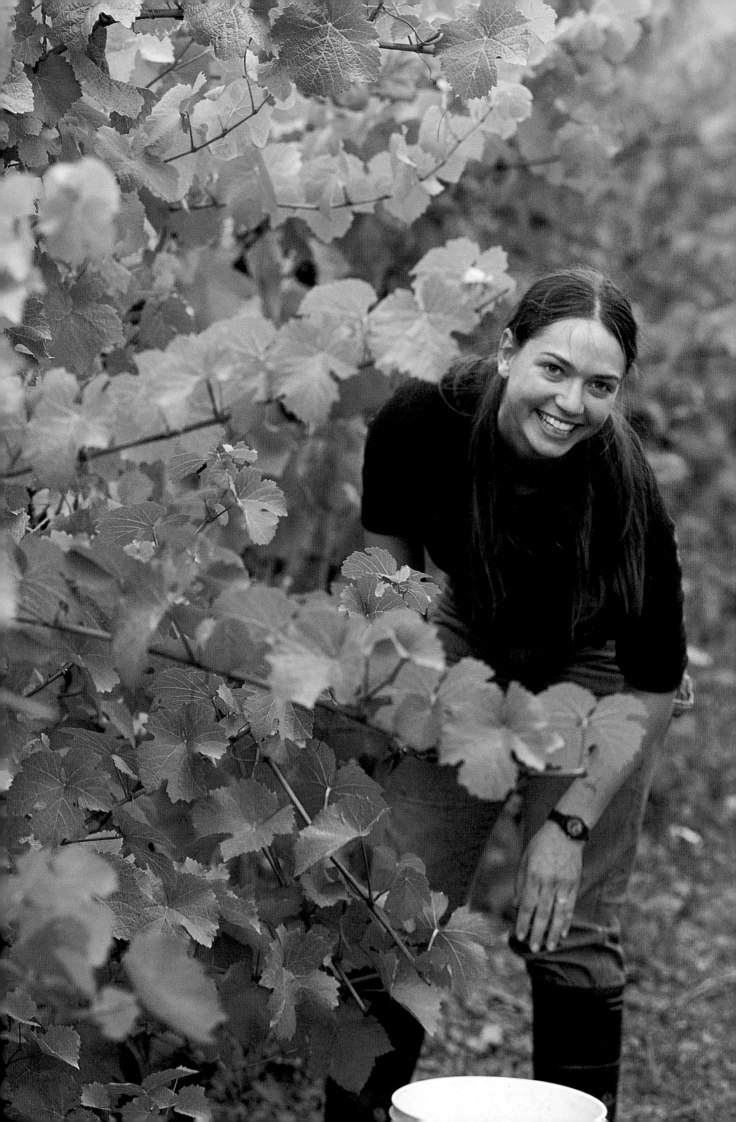

"This is one of the last places in the world where someone not born into the wine industry can start a vineyard and winery." —Nancy Ponzi

Page 14: Soft spring light and warming breezes encourage bud break in an Oregon vineyard. *Left:* Grape harvest at Tyee Vineyards near Corvallis in the southern Willamette Valley. The vineyard is planted on a Century Farm, first farmed by Tyee co-owner Dave Buchanan's grandparents in the 1880s. *Above:* Wines repose in tanks in King Estate's huge, cathedral-like tank room.

The story of Oregon wine
is a study in quiet sophistication.

Above: Unlike its French counterpart, Domaine Drouhin Oregon is a beautifully designed, modern facility chiseled into a south-facing slope of the Dundee Hills. It operates on the gravity flow principle whereby grapes enter the winery at the top level and come out in bottles at the bottom. (DDO's French counterpart, though thoroughly modern, is located in an industrial area outside Beaune.)
Right: Fall colors often herald the beginning of winegrape picking in Oregon.

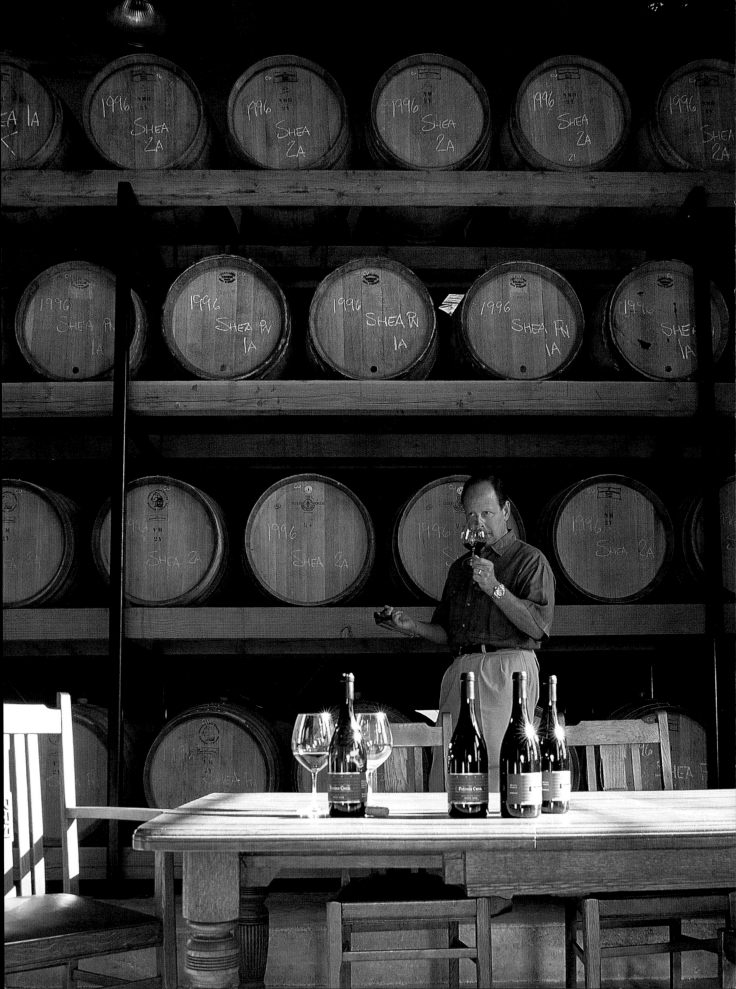

Inside, the winery is appealingly cool
and dank, offering luscious aromas
of wine and damp oak barrels.

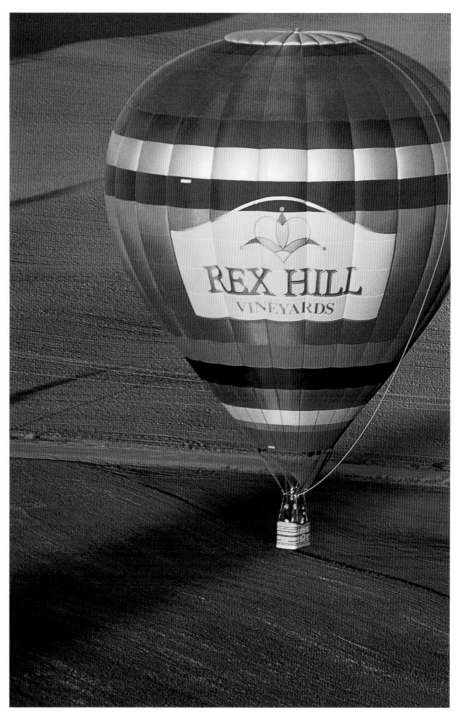

Left: Panther Creek Cellars owner Ron Kaplan samples from a barrel. The winery, located in downtown McMinnville, is housed in a historic former power station. *Above:* Hot air ballooning is catching on quickly in Oregon wine country, where the ballooning season runs from late spring through mid-October. Here, Rex Hill Vineyards and Winery's balloon soars above vineyards on a sunny summer morning. Ballooning is surely one of the best ways to view the vineyards.

Come along in summer.
The vines are in full foliage now,
a deep kelly green....

Above: A young tourist visits wineries with her parents over the busy Thanksgiving weekend. Children are welcome in the wineries, which often provide non-alcoholic beverages for designated drivers and younger visitors. *Right:* High summer brings kelly green foliage and the contrasting colors of summer lupine to WillaKenzie Estate. Owned by Bernie and Ronni LaCroute, this beautiful estate was named for the predominantly Willakenzie soil in which the vineyards are planted.

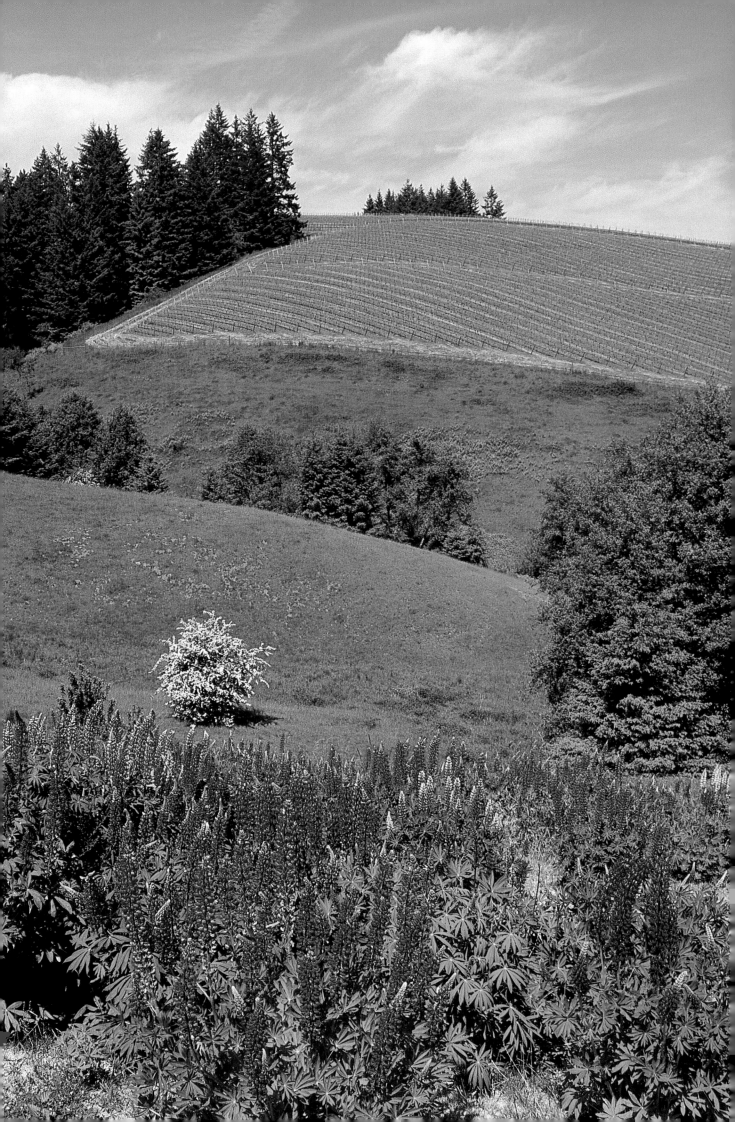

REGIONS
Willamette Valley
Washington County
Yamhill County
Dundee Hills
Polk County
Eola Hills
Umpqua Valley
Rogue Valley

Oregon's wine history goes back more than a hundred years before today's industry, which dates back only to the mid-1960s. In the 1820s Hudson's Bay Company, under the direction of Dr. John McLaughlin, established a vineyard at Fort Vancouver, just north of Portland on the Washington side of the Columbia River. This was, no doubt, the first vineyard in the Northwest. Narcissa Whitman, wife of missionary Marcus Whitman, wrote of the vineyard in her diaries in 1836.

From Washington, the industry moved south in the 1850s, as German immigrants planted vineyards in the Willamette Valley. One such site, owned by the Frank Reuter family, was located about thirty miles west of Portland. One of their winery's Rieslings won a medal in the 1904 World's Fair in St. Louis. In the late 1960s and early 1970s, this site was occupied first by the Charles Coury Winery, then by Reuter's Hill Winery, both now defunct. Since 1986 Laurel Ridge Winery has occupied the site. Some old vines from the original vineyards may still be seen at this historic estate.

As we move farther south, pioneer Jesse Applegate established vineyards near Yoncalla in the Umpqua Valley in the 1870s. Others, including the Van Pessls in the 1880s and the Doerners in the early 1900s, experimented with *Vitis vinifera* cultivation. The information left by these early grape growers influenced Richard Sommer to plant HillCrest Vineyard near Roseburg in 1961, thereby starting Oregon's modern winegrowing history.

The wine history of Oregon's southernmost grape-growing area, the Rogue Valley, began in the 1850s, when Peter Britt—Oregon pioneer, bon vivant, and Renaissance man—planted some two hundred grape varieties at his homestead near Jacksonville.

MICHAEL ETZEL
Beaux Frères

While on vacation in Portland, Michael Etzel and his wife, Jackie, were reading real estate ads in the Sunday paper when they found the vineyard property that was to become Beaux Frères. They visited the site and talked about it all the way home to Colorado Springs. "We decided we'd only do it if my brother-in-law would go in halves with us," said Etzel. The brother-in-law is wine writer Robert M. Parker Jr. He did. So they did. The Etzels moved to Oregon in fall of 1987 and began planting in spring of 1988. Over the years twenty-five acres of Pinot Noir grapes have been planted at the site outside Newberg; a barn has been converted into a winery; and Beaux Frères now has a third partner, Canadian Robert Roy. The first wines were made in 1991. The limited production of Pinot Noir remains one of Oregon's most sought-after.

Beaux Frères

But there was a long spell without any commercial *vinifera* wines being made in Oregon. Prohibition successfully put an end to the early efforts—at least as far as public manifestations were concerned. And when Americans, back from the European battlefields of World War II, once again began to show interest in fine wines, they turned to California. A few wineries there had survived prohibition—by making communion wines. Grapes grew abundantly and ripened readily. Out came the prune and walnut orchards of the Napa and Sonoma Valleys. In went winegrapes. In the 1950s and 1960s, nobody was thinking about Oregon. Conventional wisdom said it was too far north, too cold to be of interest in these endeavors.

Richard Sommer and David Lett—two major influences in Oregon's winegrowing history who are still in business today—successfully disproved the accepted wisdom of the 1960s regarding grape growing in Oregon.

First came Sommer with an agronomy degree from University of California at Davis and a passion for German wines. Sommer began planting vineyards in the Umpqua Valley near Roseburg in 1961, after researching climatic regions from British Columbia to California. He planted primarily Riesling and historically has had the best success with it. "In California the season is too warm and long for Riesling," he said.

In 1984 the federal government designated two viticultural areas in western Oregon—the Umpqua Valley and the Willamette Valley. In the early 1990s, the Rogue Valley in southern Oregon became Oregon's third designated viticultural area. Within these regions are several subregions, some of which may become designated viticultural areas in future years. And within the subregions are literally hundreds of small microclimates. All play important roles in today's Oregon wines.

Inset: Laurel Ridge Winery. *Right:* Vineyards layer the Dundee Hills, the most densely planted wine region in Oregon. Here soils are predominantly red Jory loam—considered among the best soils for winegrapes. Each soil type lends its own particular characteristics and flavors to the resulting wines, a phenomenon the French refer to as *terroir*.

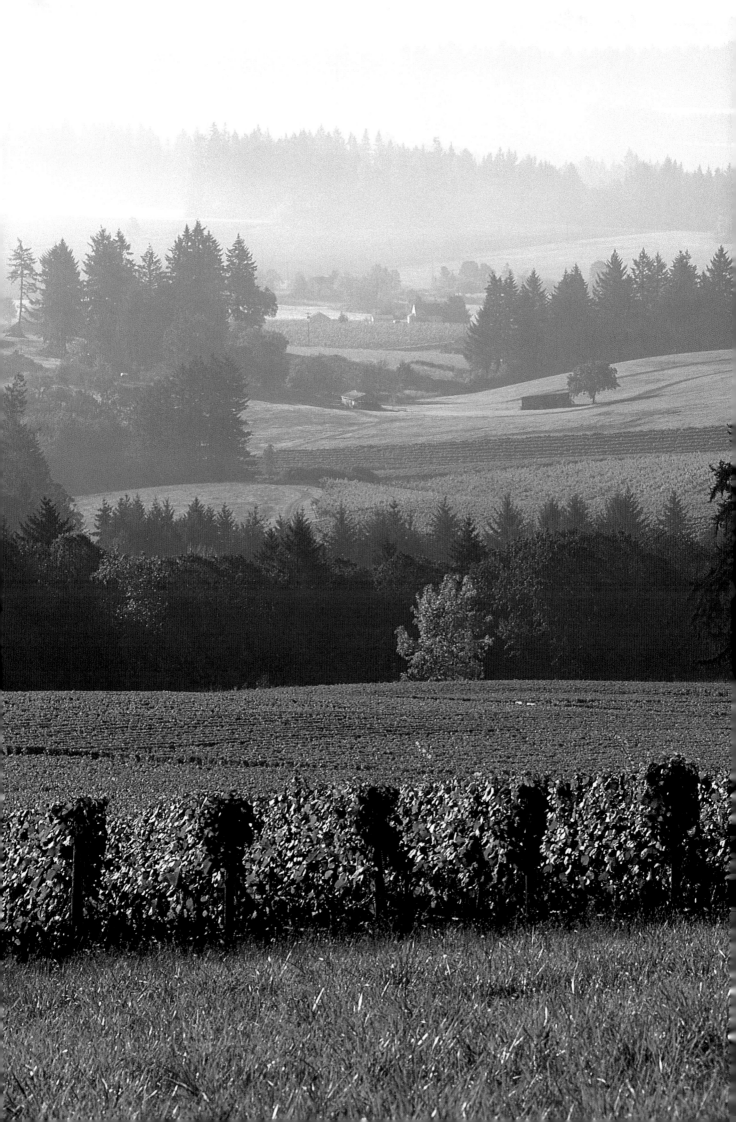

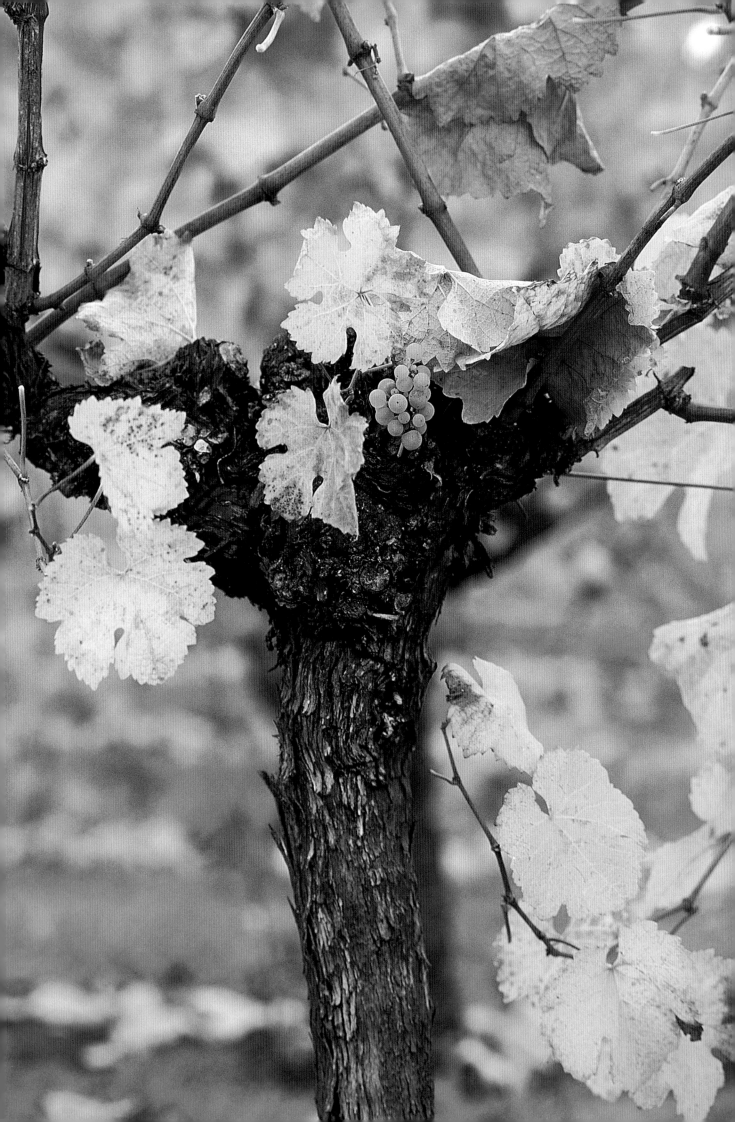

The Willamette Valley

The Willamette Valley is a huge and varied appellation. It is the farthest north—and therefore the coolest and wettest—of Oregon's three designated viticultural regions. Buffered from Pacific storms on the west by the Coast Range, the valley follows the Willamette River north to south for more than a hundred miles from the Columbia River near Portland to just south of Eugene. To the east, the Cascade Range draws the boundary between the Willamette Valley's misty, cool climate and the drier, more extreme climate of eastern Oregon.

At its widest point, this long, broad valley spans sixty miles and embodies a number of significant subregions. Overall, the climate boasts a long, gentle growing season—warm summers with cool evenings; bursts of Indian summer often shortened by maritime rains; wet, mild winters; and long, often rainy springs. In ideal years the maritime climate provides the best conditions possible for growing the cool-climate grape varieties Oregon is known for—particularly Pinot Noir. In lesser years, fall rains can be tricky and even malicious, causing reactions among winemakers ranging from minor hair pulling to outright despair. In this matter the Willamette Valley compares favorably with the Burgundy and Alsace regions of France and the Mosel region of Germany. And, like it or not, the often finicky Willamette Valley climate is the promised land for Pinot Noir in America.

An additional advantage for Willamette Valley wineries is proximity to Portland, one of the West Coast's largest cities and an international trade and tourism center. With a population base of nearly one and one-half million people and growing, Portland and environs provide a large wine-consuming population base. From Portland, tourists can visit the Willamette Valley winery of their choice in anywhere from half an hour to two hours. For these reasons, the Willamette Valley is now home to approximately two-thirds of Oregon's hundred-plus wineries.

KEN WRIGHT
Ken Wright Cellars
& Domaine Serene

KEN WRIGHT CELLARS

Ken Wright's arrival in Oregon must have looked like something out of The Grapes of Wrath—*an old truck filled with the family, their belongings, and several barrels of wine bouncing down the highway. The wine was a lovely 1985 California Cabernet Sauvignon-Cabernet Franc blend. But Wright, a former winemaker at Ventana Vineyards, came to Oregon to make Pinot Noir. He began to live his dream by founding Panther Creek Cellars in McMinnville. With his first Oregon Pinot, made during the 1986 harvest, Wright established a reputation for making rich, textured wines that are elegant but supported with lovely, soft tannins. In 1994 Wright left Panther Creek to found Ken Wright Cellars in nearby Carlton. His commitment still is to a small, hands-on winery he can control himself. His vision of Pinot Noir has earned him a cult following. In addition to making his own Pinot Noir, Mélon, and Chardonnay, Wright is winemaker for Domaine Serene, a small winery owned by Minnesotans Ken and Grace Evenstad.*

Left: Old grapevines are characterized by their thick trunks with nobby tops that reflect years of careful pruning. This old vine, shown in early summer, displays an immature grape cluster.

Washington County

Of the Willamette Valley's many subregions, Washington County is the closest to Portland. Indeed, Ponzi Vineyards, founded in the early 1970s in rural Washington County, now abuts a subdivision—not exactly what the Ponzis had in mind when they planted their first vineyard, but its location is handy to visitors.

The simple geography of county lines sets Washington County apart from Yamhill County. Both boast similar soil types and climates. Washington County lies just west of Portland and is drained by the Tualatin River and its tributaries. Home to seven wineries, it is separated from Yamhill County by the Chehalem Ridge.

Charles Coury started Washington County's first modern-day winery on the property near Forest Grove that had been settled by the Reuter family in the 1850s. He purchased the land in 1966, intending to focus on Riesling. Though a vocal spokesman for the

Right: French-born winemaker Jacques Tardy grew up in a winemaking family in Burgundy. He came to the United States to be free from the restrictions of "the government ... and grandpa."

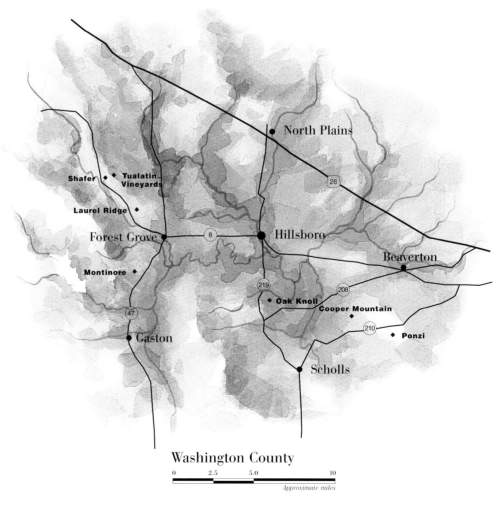

Washington County

0 2.5 5.0 10

Approximate miles

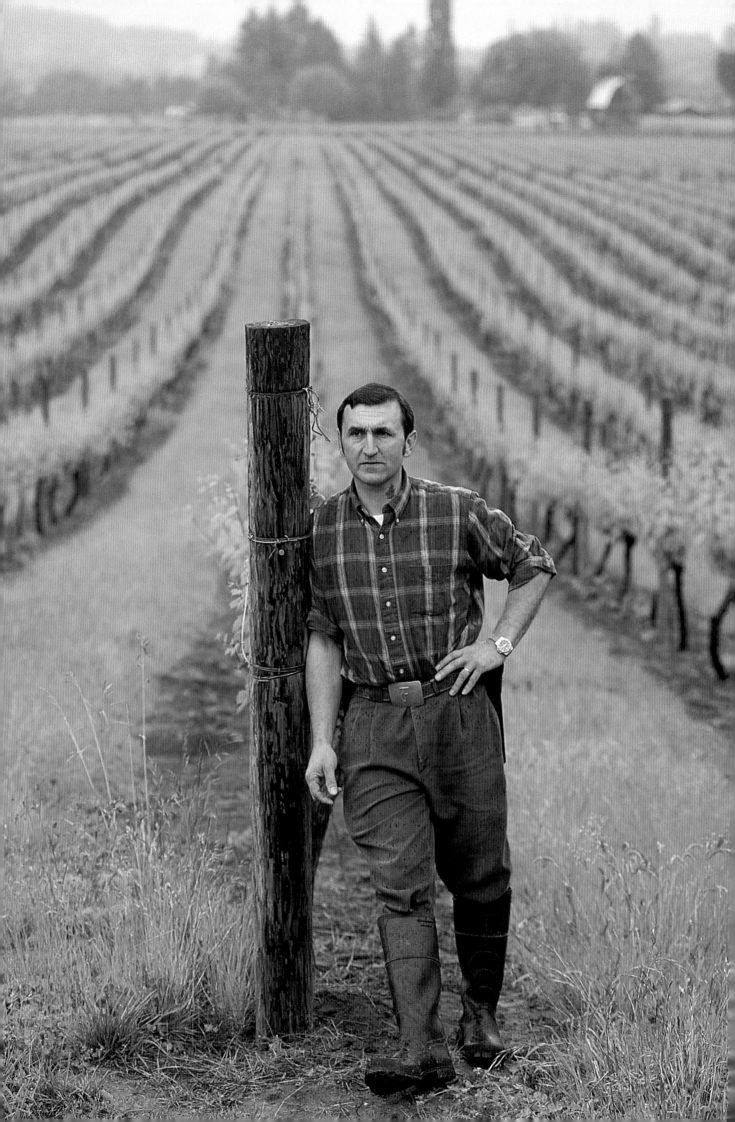

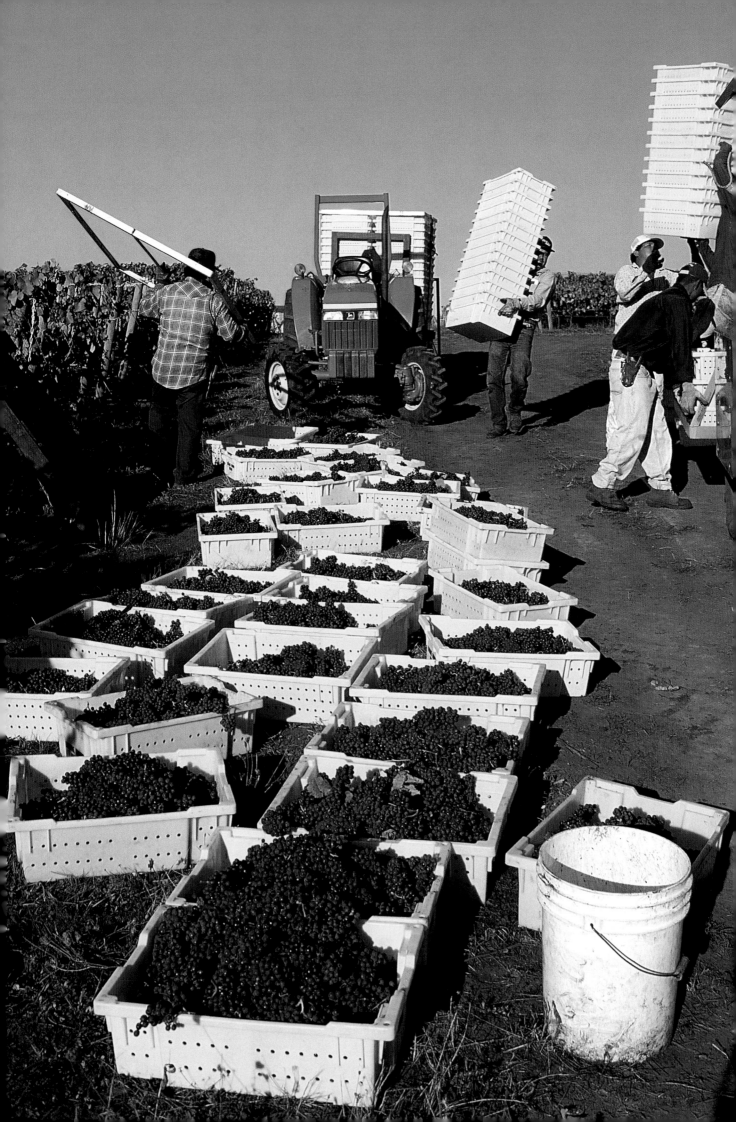

Oregon wine industry, Coury enjoyed only a few vintages before he went out of business. The more stable Washington County wine pioneers were the Ponzis, the Vuylsteke family of Oak Knoll Winery, and Bill and Virginia Fuller of Tualatin Vineyards.

The Ponzis spent five years studying different areas before coming to Oregon in 1970 and locating in Washington County. "We found the place we thought would produce the finest wine—Pinot Noir—and just did it," said Nancy Ponzi. "We moved here with the intention of raising grapes." Though fame for Pinot Noir came later, the Ponzis first made their name with a delicious Riesling. Unlike their later competitors, many of whom made sweet or slightly sweet Rieslings, the Ponzis made their Riesling in the bone-dry Alsatian style. It paired well with a great variety of foods and found them an exclusive niche in the marketplace.

Left: In Oregon, grapes are handpicked at harvest and transported to nearby wineries in totes such as these yellow ones. With this gentle handling of the fruit, grapes remain whole and undamaged until they are crushed at the winery.

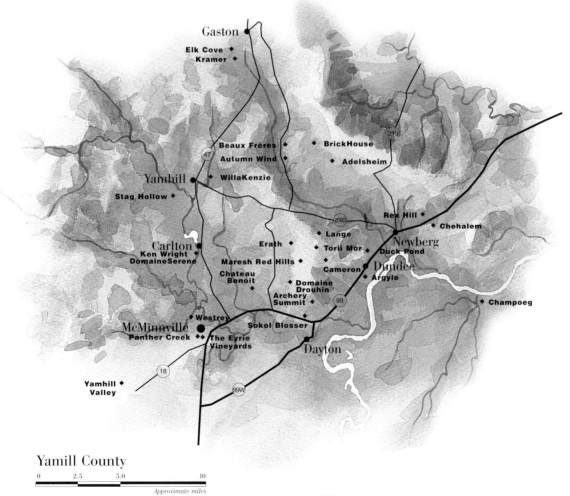

Yamill County

0 2.5 5.0 10

Approximate miles

In 1970 the Vuylsteke family founded Oak Knoll Winery. Although known for their *vinifera* wines today, they concentrated on fruit and berry wines for their first several years.

The third arrivals on the Washington County grape-growing scene were Bill and Virginia Fuller, also from California. Unlike other newcomers, who found themselves learning winemaking on the job, Bill Fuller came to Oregon with a master's degree in enology from the University of California at Davis and more than a decade of winemaking experience, including nine years as chief chemist at Louis Martini Winery in Napa Valley. Financial backing came from William Malkmus, a California investment banker. The site the Fullers chose, located southwest of Forest Grove, features south-sloping hillsides and has proven particularly conducive to Chardonnay.

It should be noted that the above wineries, as well as most of the pioneers in Yamhill County, purchased winegrapes in early years from established vineyards in eastern Washington. As their Oregon vineyards matured, most of the wineries discontinued this practice. Today Oregon wineries rely almost entirely on grapes grown in their own and nearby vineyards.

Yamhill County

More than thirty wineries make Yamhill County their home, representing the largest concentration of wineries in Oregon. First of the modern-day vintners in this bountiful valley was David Lett, who moved from California in 1965 with three thousand Pinot Noir cuttings and purchased land in the Dundee Hills.

Lett had read about Oregon in *National Geographic* and studied eighty years' worth of Willamette Valley climatic records. "In 1965 I arrived here with this tight theory that these Pinot Noir grapes belonged in this climate," he said. His theory worked. But at the time, others—particularly anyone associated with the

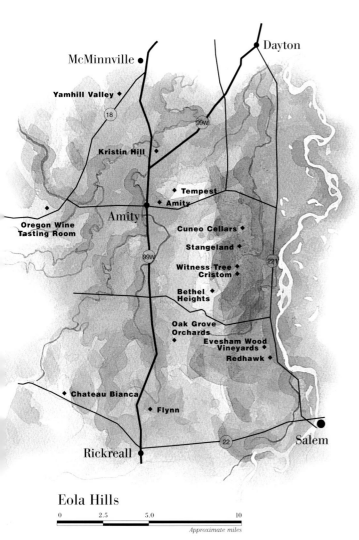

Eola Hills

0 2.5 5.0 10

Approximate miles

Inset: Oak Knoll Winery. *Right:* The Witness Tree, used as a reference point by surveyors platting the Eola Hills area near Salem, overlooks Witness Tree Vineyard. The tree is depicted on the winery's label.

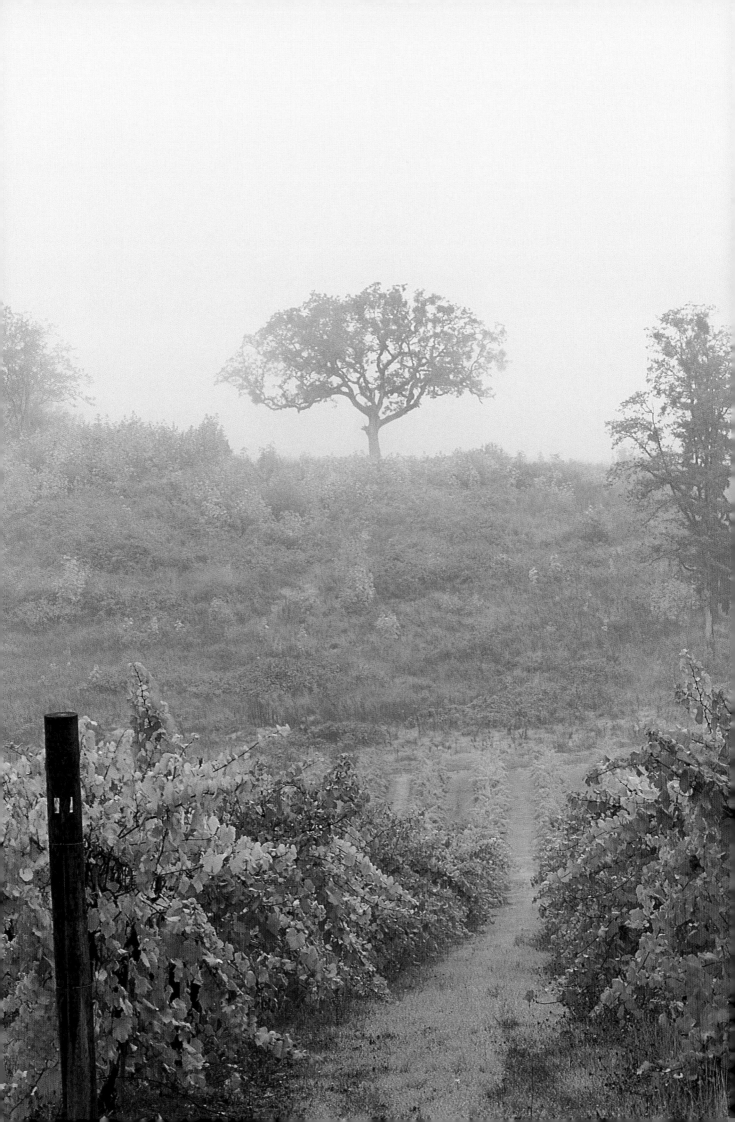

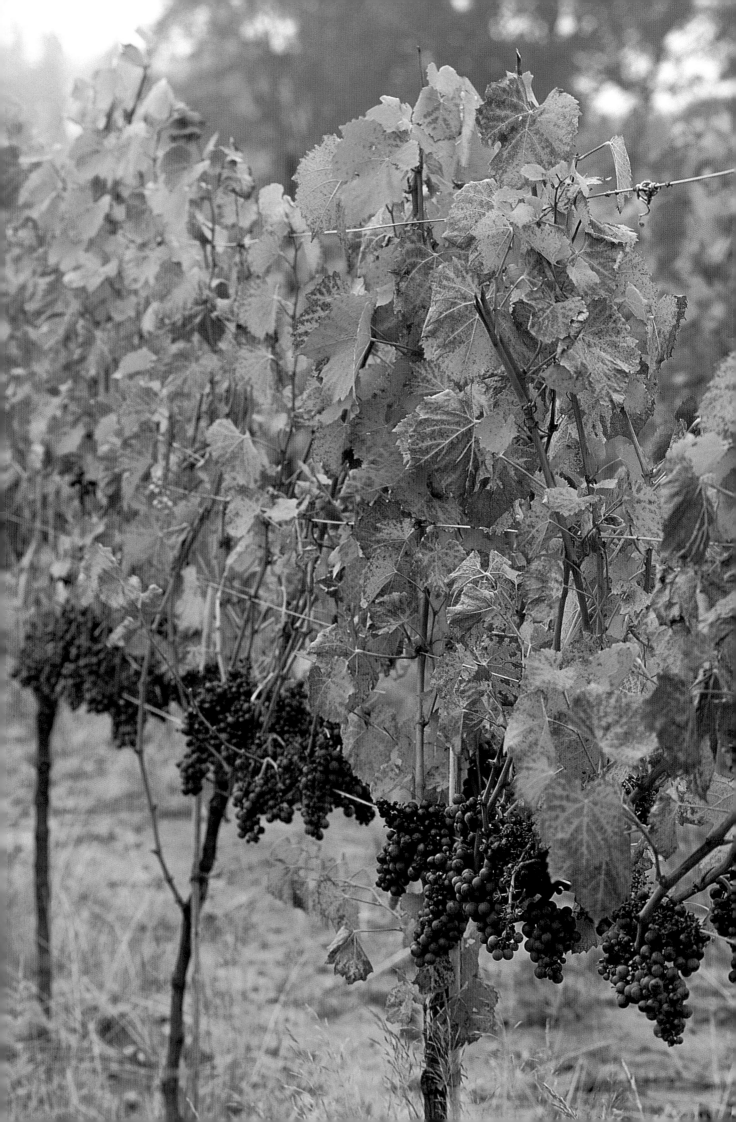

University of California at Davis—thought Lett was crazy for planting so far north. However, he was not the only crazy one. Dick Erath, an electrical engineer and long-time home winemaker, arrived in Oregon with his family in 1969 and planted Chardonnay on the Chehalem Ridge just north of the Dundee Hills.

By the late 1970s, the Yamhill County wine community had four more members—Amity Vineyards, first vintage in 1976; Sokol Blosser Winery and Elk Cove Vineyards, first vintage in 1977; and Adelsheim Vineyard, first vintage in 1978. This set the stage for the explosion of small wineries that occurred in Yamhill County in the 1980s and continues through the 1990s.

With more similarities than differences, both climatically and in proximity to Portland, one might ask why Yamhill County had thirty-four wineries to Washington County's seven, and ninety-eight vineyards to Washington County's forty-one by 1997. The answer lies in the orientation of hillsides. Throughout the generally broad, flat Willamette Valley are many hills created millions of years ago by volcanic uprisings. It is on the southern and southwestern slopes of these hills that most Willamette Valley vineyards are planted. Yamhill County is blessed with three chains of interlocking hills—the Chehalem Ridge, the Dundee Hills, and the northernmost part of the Eola Hills. These generally south-facing hillsides provide a critical mass of ideal grape-growing sites in Yamhill County not found to such an extent anywhere else in the Willamette Valley.

In addition to geography, a significant event in 1979 focused the wine world's attention on Yamhill County. That summer a competition sponsored by Gault-Millau, publishers of *Le Nouveau Guide,* pitted some of France's best wines against selected wines from other parts of the globe. In the competition, The Eyrie Vineyards' 1975 Pinot Noir South Block Reserve and a 1976 Pinot Noir from Knudsen Erath Winery outscored many of the best Burgundies France had to offer. Burgundian wine magnate Robert Drouhin could not believe the results and, early in 1980, staged his own competition in Beaune. There, with the same wines and a different panel of judges, The Eyrie Vineyards'

JOHN PAUL
Cameron Winery

CAMERON
Distinctive Wines From Dundee

Like many Oregon winemakers, John Paul followed a circuitous route to his calling. He earned a Ph.D. from the Scripps Institute of Oceanography in California and was a research associate in plant biochemistry at the University of California at Berkeley when he became interested in winemaking in Oregon. He worked the 1978 crush at Sokol Blosser Winery. After serving as assistant winemaker at two California wineries, Paul spent time in France learning about traditional winemaking in Burgundy. Spring of 1983 found him working the crush at Cooper's Creek Vineyard in New Zealand. He and his family moved to Oregon in time for the 1984 crush— one of the worst vintages in recent history—and Cameron Winery was founded. The wines, by the way, were excellent. Cameron's production still centers around the two grapes that brought Paul here. He also makes the occasional late-harvest Riesling and a delicious Pinot Blanc.

Pages 36-37: Freedom Hill Vineyard near Salem employs the lyre trellis system. Though not widely used in Oregon, the lyre trellis divides the grape canopy to promote better air flow and greater sun exposure to ripening grapes. *Left:* Ripe Pinot Noir grapes await picking. Although grapes may have achieved optimum sugar levels, they often are left to hang several days, weather permitting, to allow further development of flavors.

DICK ERATH
Erath Vineyards Winery

Another California native, Dick Erath, ranks as one of Oregon's most influential wine pioneers. He moved with his family to Dundee in 1968, and in 1969 planted his first four acres of winegrapes. He also planted a vineyard for lumber mogul Cal Knudsen. Erath released his first commercial wines from the 1972 vintage under the Erath Vineyards label, but soon he and Knudsen forged a partnership, and the winery became Knudsen Erath. In the winery, Erath's passion was for Pinot Noir and Riesling, but his true love is grape growing. For years he has run a successful nursery from which many Oregon grape growers have purchased their first vineyard stock. In 1988 Erath purchased Knudsen's share of the winery, and today the label is again Erath Vineyards. Erath shares winemaking duties with Rob Stuart. Exciting Chardonnays from recently planted Dijon clones share the limelight with the Pinot Noirs. Both winemakers are excited about the winery's Pinot Gris, Pinot Blanc, and small batches of Dolcetto and Arneis.

Pinot did it again, scoring second place in the competition by a fraction of a percentage point over Drouhin's 1959 Chambolle-Musigny. Overnight, every Burgundy worshiper on the planet knew where Oregon's Dundee Hills were!

Perhaps a third reason Yamhill County stands out in the minds of wine connoisseurs is only indirectly connected with vineyards and wineries. In February 1977 Nick's Italian Cafe opened in McMinnville. With his restaurant's opening, Nick Peirano moved his family from California and put everything he had on the line. With his deft touch in the kitchen, his love of wines, and the table-side manner of an Italian grandmother, Peirano won the hearts of Willamette Valley wine producers. And because of his symbiotic relationship with the then-youthful wine industry, he was successful. His establishment quickly became the industry's unofficial hangout. A visit to his restaurant is a historic event.

Nick Peirano and his sidekick John West gave the industry its first truly wine-friendly restaurant between Portland and Eugene. When no other restaurants were serving them, his restaurant featured only Oregon wines and over the years gained a reputation for serving older vintages and special releases not found elsewhere. Nick's is a place where those in the know can receive advice on upcoming rites of passage, relive recent tragedies and triumphs, and learn how to make spinach ravioli from an expert. While Nick's has been written up in periodicals around the world, the place has not changed a great deal since it opened. It still has the counter with soda fountain stools and the old booths characteristic of a cafe from the 1950s. Visitors today often find Nick behind the counter, a little grayer perhaps, but the same friendly, self-effacing soul sipping a beer and dispensing advice along with his Italian home-style food. Perhaps the

Inset: Nick Peirano. *Right:* Knudsen Vineyard is one of the largest contiguous vineyards in the Willamette Valley. Most of its grapes go to Argyle Winery in Dundee, where they are made into sparkling wines. The building complex in the upper left of the photo is Erath Vineyards Winery.

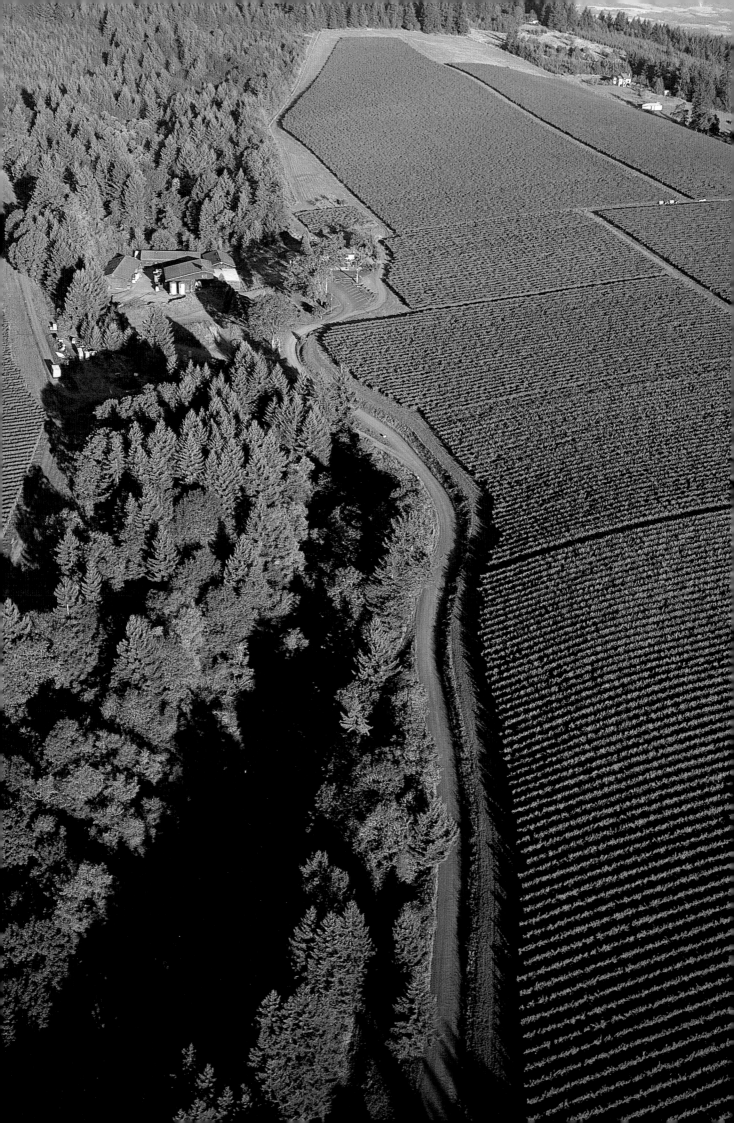

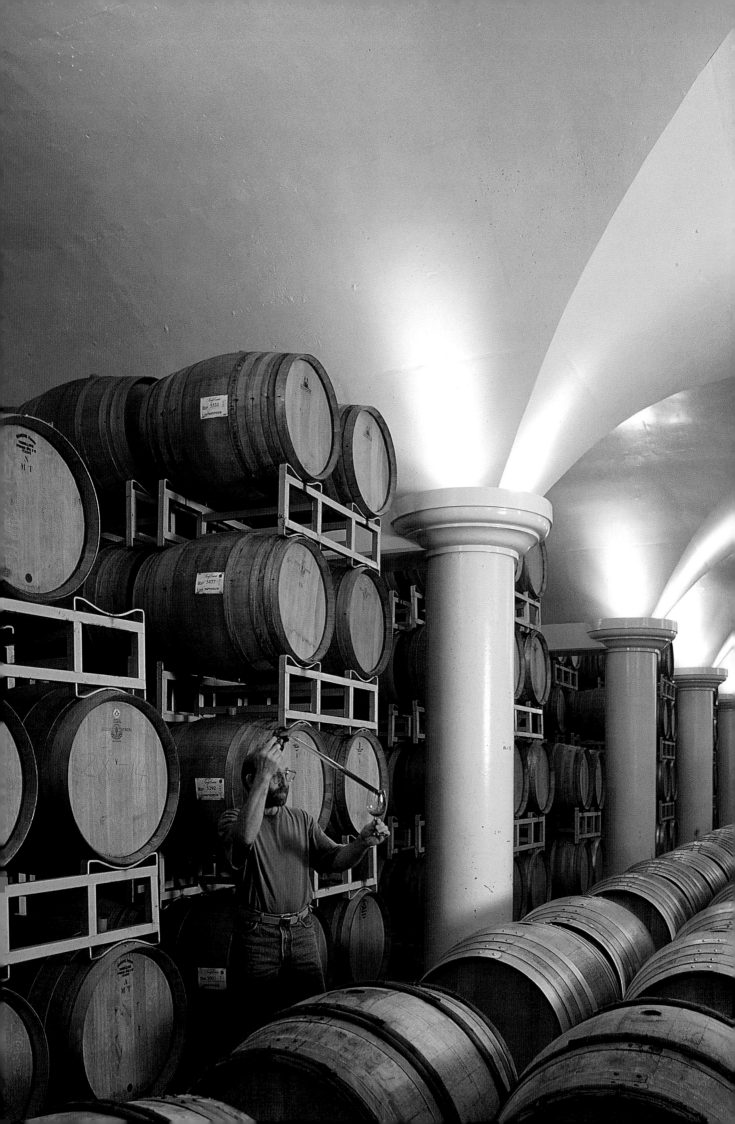

fact of Nick's existence encouraged other fine restaurants to open in Yamhill County, followed by a few bed-and-breakfasts. Peirano himself did encourage those who were new to the wine business and featured their wines.

Nick's influence notwithstanding, the Dundee Hills are home to the majority of Yamhill County's nearly twenty-five hundred acres of winegrapes. Most of the vineyards are not visible from Highway 99W, which cuts through the center of the valley. But a small detour off 99W in downtown Dundee leads the wine adventurer upward to discover hillside after hillside covered with vineyards, including those belonging to Lange Winery, Torii Mor Winery, Cameron Winery, Erath Vineyards Winery, Knudsen Vineyards, Acme Wineworks, and many others—growers whose names grace the bottles of many fine vineyard-designated wines.

Farther down the highway, to the right, one passes the vineyards of Sokol Blosser Winery, The Eyrie Vineyards, Domaine Drouhin Oregon, Archery Summit Winery, and others. The series of Dundee Hills tapers to an end a few miles west of Dundee where Highway 18 and 99W make a Y. At this junction is Stoller Vineyards, a new operation that eventually will be home to more than two hundred acres of vineyard, one of Oregon's largest single sites.

Just north of the Dundee Hills, the Chehalem Ridge forms a similar series of hillocks that make up another specialized subregion known for its deeply colored, intensely flavored Pinot Noir. Adelsheim Vineyard was first to plant winegrapes on this ridge. Following Adelsheim's success, other vineyards were established, including Adams Vinyard, Ridgecrest Vineyards, Autumn Wind Vineyard, Beaux Frères, Brick House Vineyards, and Rex Hill's Kings Ridge Vineyard. Alike climatically, the Chehalem Ridge and Dundee Hills differ in that Chehalem Ridge has predominantly Willakenzie soil type, as opposed to the Jory loam found in the Dundee Hills.

South Willamette

| 0 | 10 | 20 | 30 |

Approximate miles

Left: The policy at King Estate Winery is to work with a team of winemakers, plus interns from viticultural regions worldwide. Here a member of the team checks Pinot Noir in the winery's barrel-aging area.

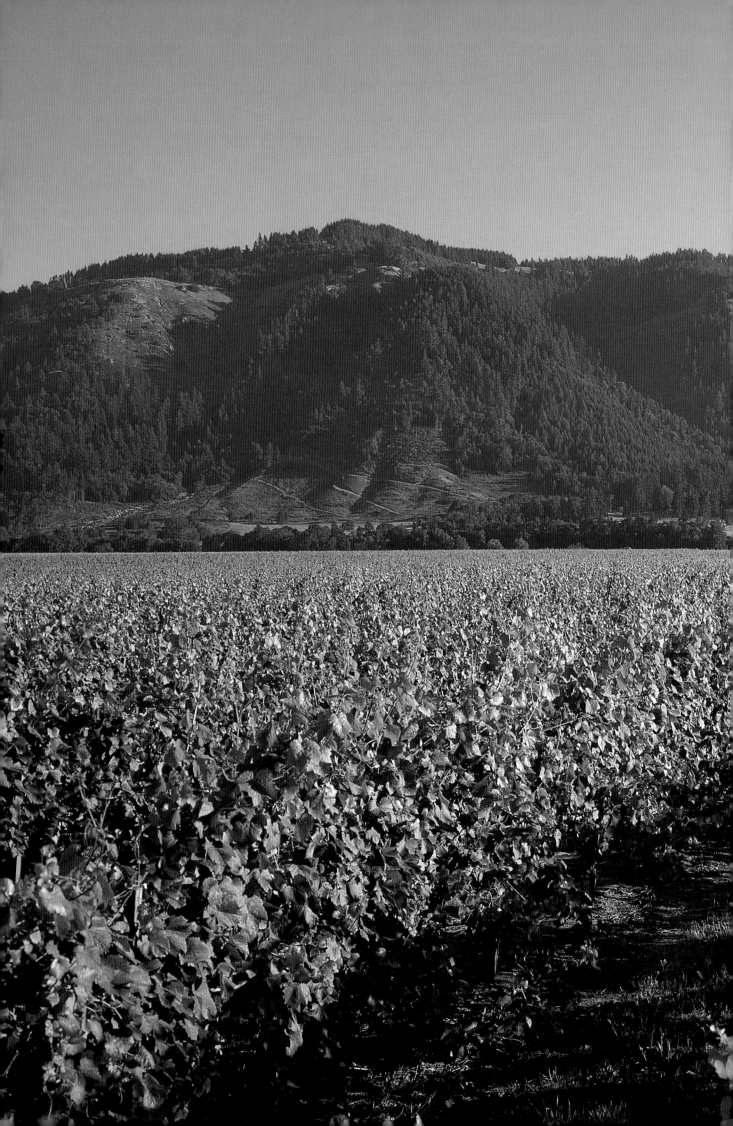

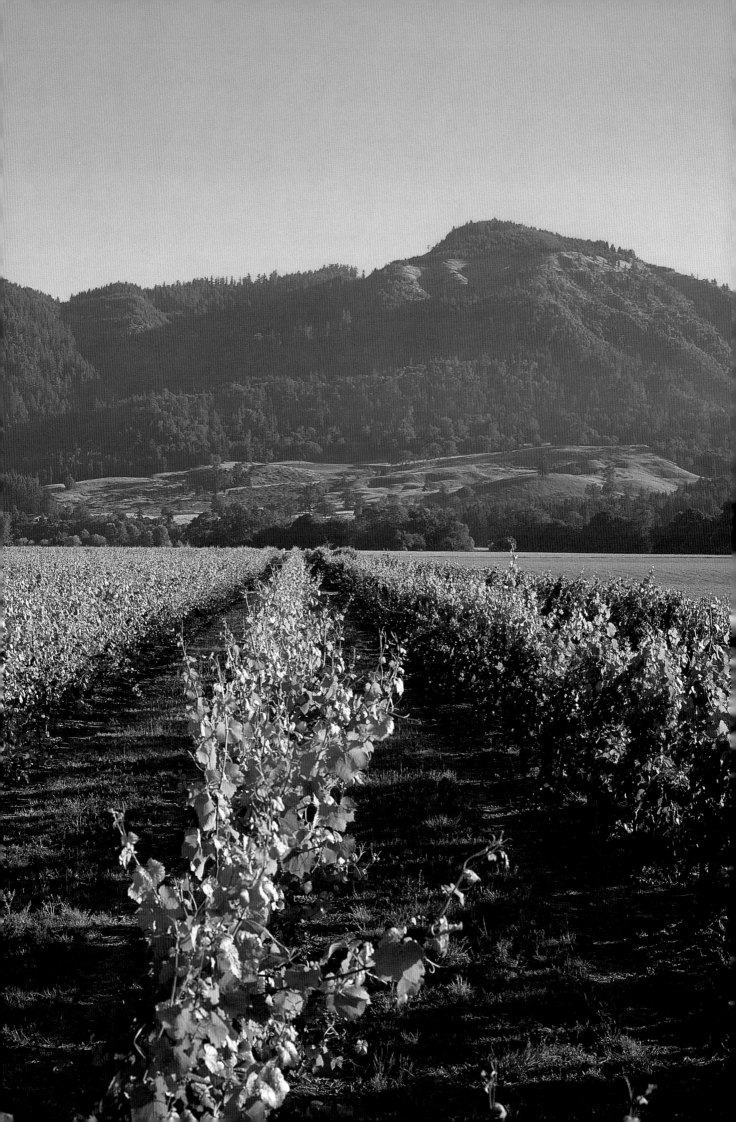

SARAH POWELL
Foris Vineyards Winery

Foris Vineyards winemaker Sarah Powell began her post-secondary education at the University of Washington, but something lured her to France, first to study French at La Sorbonne in Paris in 1985 and then to study enology and viticulture at Lycée Agricole de Macon Davaye in Burgundy. She worked the crush at Chateau St. Phillippe d'Aiguille in Bordeaux in 1986, then returned to the States to pursue a bachelor's degree in fermentation science at the University of California at Davis. Powell worked in several of the world's wine-producing regions following her graduation from the University of California at Davis— including stints in Napa Valley, South Africa, Washington, Australia, and New Zealand—before returning to the Northwest to become wine-maker at Foris Vineyards Winery. Since 1991 Foris has had her undivided attention, and the wines have benefitted from her experience.

FORIS

The Eola Hills/Marion and Polk Counties

South of McMinnville but still within Yamhill County, more ancient volcanic eruptions form the beginning of the Eola Hills, a series of hills running north to south into Polk County. As with the Chehalem Ridge and the Dundee Hills, the Eola Hills are ideally suited to grape growing by virtue of their orientation and soils. A concentration of wineries plus several well-known vineyards not associated with wineries abide on these sunny, predominantly south-westerly slopes. So renowned are the vineyards that people in the wine community think of the Eola Hills as a very special subregion.

One of the first vineyards in the Eola Hills was planted in 1974 by Myron Redford, owner and founder of Amity Vineyards. In the mid-1970s, twin brothers Ted and Terry Casteel and their families purchased a young fourteen-acre vineyard a few miles south of Redford, added to it, and called it Bethel Heights Vineyard. For years Bethel Heights sold its grapes to other Oregon wineries before its first commercial harvest in 1984. Meanwhile, Bethel Heights acquired a bevy of neighbors. Seven Springs Vineyard, O'Connor Vineyards, and Temperance Hill Vineyards are just a few of the reputable vineyard names that grace some of Oregon's best bottles of wine—which include wines produced by Adelsheim Vineyard and Domaine Drouhin Oregon. Other notable names in the area include Evesham Wood Vineyards, Cristom Vineyards, Witness Tree Vineyard, and, in nearby Salem, St. Innocent Winery.

Farther south along Highway 99W, the valley flattens somewhat. Vineyards are sparser, and some wineries, such as Eola Hills Wine Cellars in Rickreall, make excellent wines from nearby Eola Hills fruit.

A large young winery south of Salem along Interstate 5 is Willamette Valley Vineyards. Founded in 1989, the winery and surrounding vineyards are the result of a fund-raising campaign by winery president Jim Bernau. The facility was built by financial investments made by more than two thousand shareholders. The winery and vineyards can be seen from the freeway.

Pages 44 & 45: The vineyards at Henry Estate near Roseburg are planted on the valley floor on property homesteaded by the Henry family 130 years ago. *Right:* An example of a lyre or double-curtain trellis system is found at Foris Vineyards Winery in the Rogue Valley appellation. Located in the cool eastern corner of the Rogue appellation near Cave Junction, Foris uses this system to encourage sun contact with the grapes.

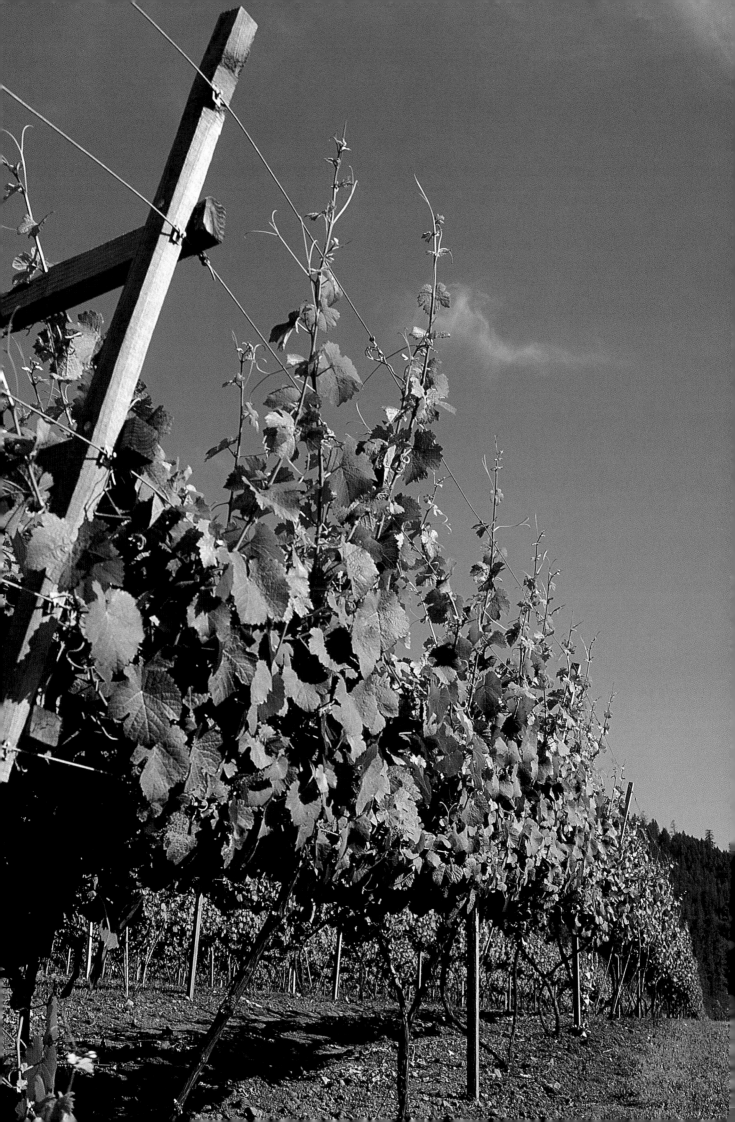

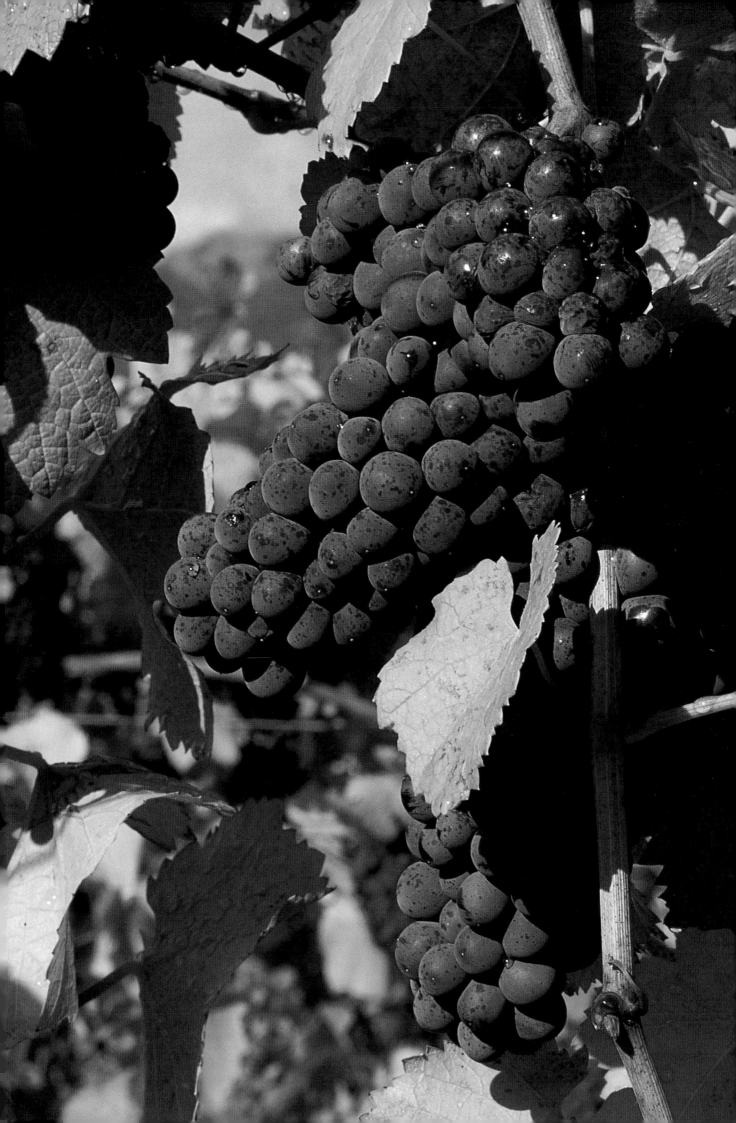

Several wineries, among them Flynn Vineyards and Eola Hills Wine Cellars, are accessible from the highway. Here the vineyards and wineries become more sporadic and site-specific. This trend continues into the south Willamette Valley.

South Willamette Valley

Wineries in the south Willamette Valley begin in the Corvallis area and end south of Eugene. Hinman Vineyards/Silvan Ridge, located south of Eugene, was the first of today's operating wineries to open—in 1979. Founder Doyle Hinman sold the winery several years ago, and it is now owned by Eugene business-woman Carolyn Chambers. Alpine Vineyards, south-west of Corvallis, made its first wines in 1980. Tyee Wine Cellars near Corvallis produces some of this subregion's finest wines. Its first commercial harvest was in 1985.

Folks from out-of-state are responsible for the south Willamette Valley's largest ventures. California vintners Steve Girard and Carl Doumani and their investors own a large estate near Monroe, with more than eighty acres planted to Pinot Noir and Nebbiolo. Clearly, the climate is a few degrees warmer here year-round than in the northern Willamette Valley. Benton Lane Vineyards, named for the two counties the estate touches, has kept a fairly low profile. The first wines were made in 1991.

King Estate Winery, located south of Eugene at Lorane, includes a 550-acre estate and the multi-million-dollar winery owned by the King family, who were originally from Kansas City, Missouri. The first wines were from the 1992 vintage—from grapes purchased from a number of southern Willamette Valley vineyards.

The south Willamette Valley shows every indication of being good for grape growing, provided the right sites are selected. Although vineyards and wineries are rather scattered, overall the area does produce some fine winegrapes.

Umpqua Valley

0 2.5 5.0 10

Approximate miles

Left: Pinot Noir has always been the rarest of the noble grape varieties, with approximately forty thousand acres planted world-wide, most of them in Burgundy. Some three thousand acres of Pinot Noir are planted in Oregon, making it the most planted variety in the state.

49

The Umpqua Valley

While the Willamette Valley is a complicated appellation due to its size, lay of the land, and the fact that it encompasses several counties, the Umpqua Valley appellation is fairly easy to define. It is made up of the lowlands of Douglas County between the Cascade and Coastal Ranges, and extends to the thousand-foot elevation.

"When we wrote it up, we found no one who would be excluded. Even the newest plantings could be incorporated," said David Adelsheim, who wrote the applications for both the Willamette and Umpqua regions when they became federally designated viticultural areas in 1984. Douglas County is heavily forested, and there is virtually no agricultural activity above the thousand-foot level.

Rather than a long, wide valley such as the Willamette, the Umpqua consists of a series of interconnected small valleys with river drainages, known as "the hundred valleys of the Umpqua." Climatically, the Umpqua is more *like* the Willamette Valley than it is different. Both lie between the same mountain ranges. Both have moderate rainfall because of the coastal influence.

But Richard Sommer of HillCrest Vineyard had specific reasons for choosing the Umpqua when he began planting his vineyard there in 1961. "I liked the temperature summations," he said. "The Medford-Ashland area was a little too high and dry. The Willamette Valley was cool and wet."

Right: A swan glides on the holding pond at Foris Vineyards Winery in southern Oregon. At Foris water is pumped from the holding pond to cool the winery on warm summer days.

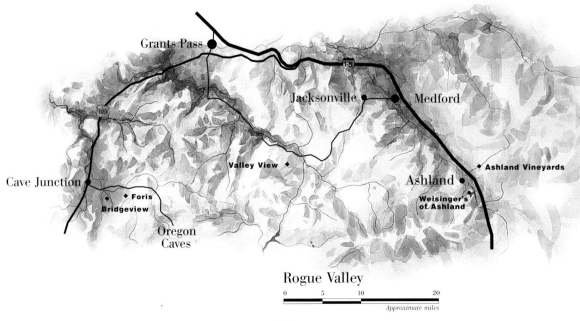

Rogue Valley

0 5 10 20

Approximate miles

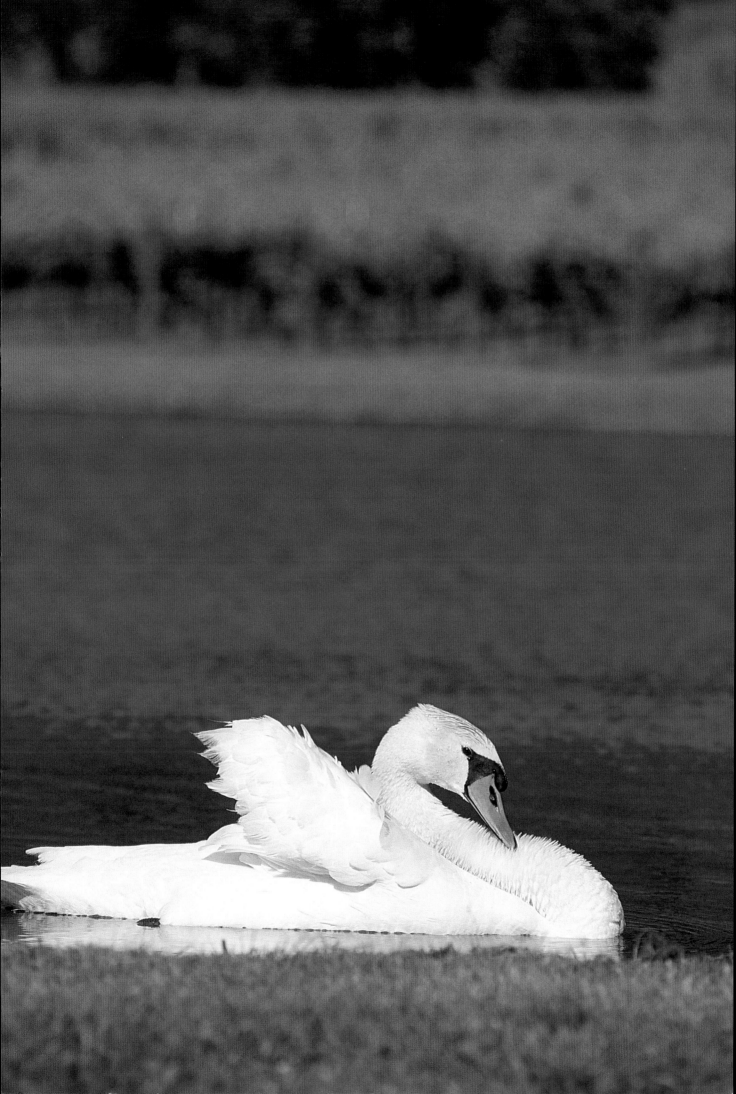

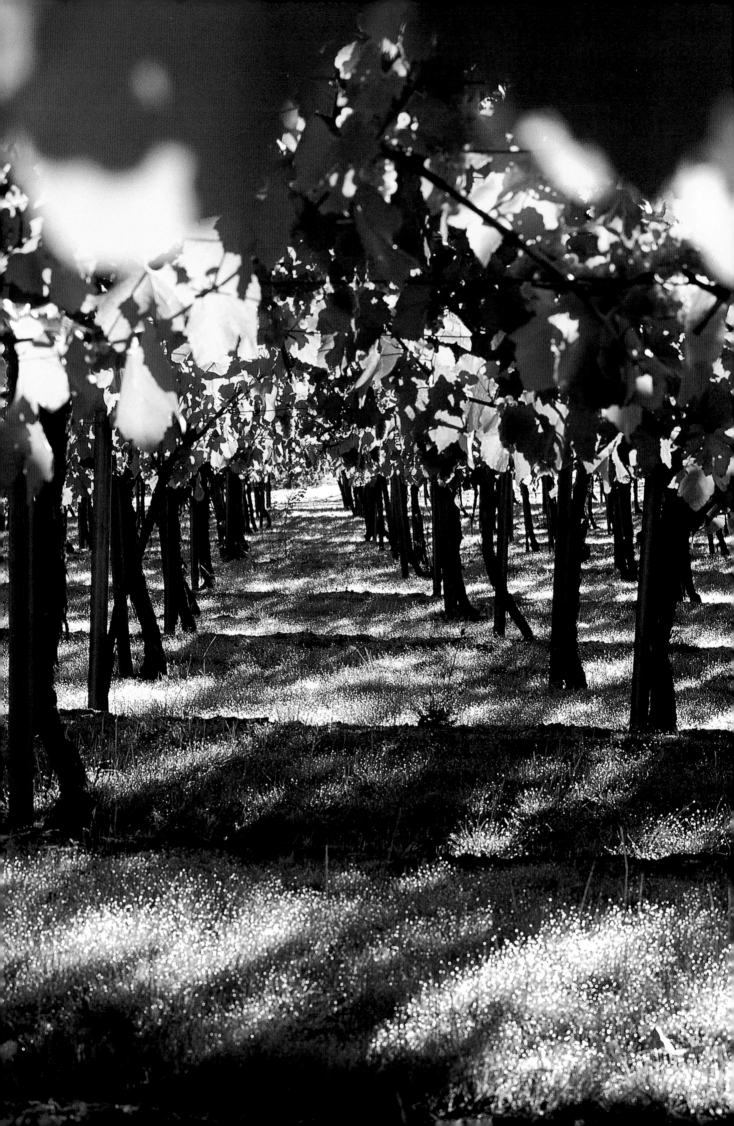

Indeed, the climate is historically warmer in summer and cooler in winter, with a slightly later spring and longer, drier fall than the Willamette Valley. It is host to a wide variety of soil types and receives about thirty inches of rainfall yearly, which is adequate for grapes. While Riesling, Pinot Noir, and Chardonnay are the most accepted varieties in the Umpqua region, Adelsheim has believed for many years that the area has more potential for the Bordelais varieties—Cabernet Sauvignon, Merlot, Sauvignon Blanc, and Semillon. In fact, some of Sommer's most notable wines in past years were Cabernet Sauvignons.

Theoretically, these conditions should make the Umpqua Valley extremely desirable as a winegrowing region. In practice, this is not the case. The Umpqua region is home to only a handful of wineries, and only a couple of these have achieved any significant distribution out of area. The Umpqua Valley is an isolated region two hundred miles south of Portland. With no proximity to large-city hotels, restaurants, and night life—not to mention distribution networks—the area has not been able to sustain the critical mass of wineries needed to make it a major player in the world wine market. As Adelsheim noted some years back, "The region simply hasn't been explored in terms of geographic and winemaking potential." Alas, this is still the case.

The Rogue Valley

Newest of Oregon's three federally designated viticultural areas, the Rogue Valley is a large and varied appellation made up of three subregions. Like the Umpqua, this region contains only a handful of wineries, and they are widely scattered.

The first subregion is the Illinois Valley abutting Highway 199 on the western side of the Rogue Valley. Higher and cooler than other parts of the region, the Illinois Valley is best known for its cool-climate grapes such as Pinot Noir, Riesling, Chardonnay, Pinot Gris, and Gewurztraminer. It is home to two notable wineries—Bridgeview Vineyards and Foris Vineyards Winery—both in the Cave Junction area.

DON & WENDY LANGE
Lange Winery

A high school English teacher, song writer, and recording artist for fifteen years, Don Lange began working in Santa Barbara–area wineries in 1979. His resumé includes stints at Sanford & Benedict, Ballard Canyon, and Austin Cellars. During this time he developed a keen interest in Pinot Noir and calls it "the sole motivating factor for moving to Oregon." The Langes moved to the Dundee Hills and celebrated their first crush in 1987. Since then, they have established a reputation for serving "dry wit and dry wine" at the winery's modest tasting room. Don is vineyard manager and winemaker. Wendy, whose background is in English literature and dance, helps with the crush and manages the tasting room.

Left: A canopy of mature vines at Durant Vineyard provides a cool respite from summer heat. Durant is located near Sokol Blosser Winery's vineyards in the Dundee Hills.

Inland, boasting a warmer and drier climate, the Applegate Valley is best known for its Bordelais varieties. Valley View Winery, the benchmark winery for this subregion, is known for its Cabernet Sauvignon, Sauvignon Blanc, Merlot, and Chardonnay.

Farther west, in the Rogue River subregion, the climate is warmer still. This subregion extends along Interstate 5 from Grants Pass south to Ashland and is also suitable for Chardonnay and the Bordeaux varieties.

As in the Umpqua region, a critical mass of wineries is lacking; the region has not been explored fully in terms of its grape-growing and winemaking potential.

Other Regions

Oregon's two other appellations really belong to Washington. The huge Columbia Valley appellation encompasses the Columbia River basin, primarily eastern Washington. However, on the Oregon side of the Columbia River near Boardman and in the Hood River area are Oregon vineyards that are part of this wine region. Likewise, Washington's Walla Walla appellation lapses into Oregon's Milton-Freewater area.

The two regions combined have only a handful of wineries. The Hood River area is a delightful place to spend a weekend and enjoy the wineries on both sides of the river. Near Walla Walla, Seven Hills Winery in Milton-Freewater, Oregon, shares the stage with some of Washington's finest.

Inset: Bridgeview Vineyards. *Right:* An Australian vineyard helper works the crush at Ponzi Vineyards. Each year, many interns from Europe, Australia, and New Zealand help with the grape harvest and learn about winemaking in Oregon.

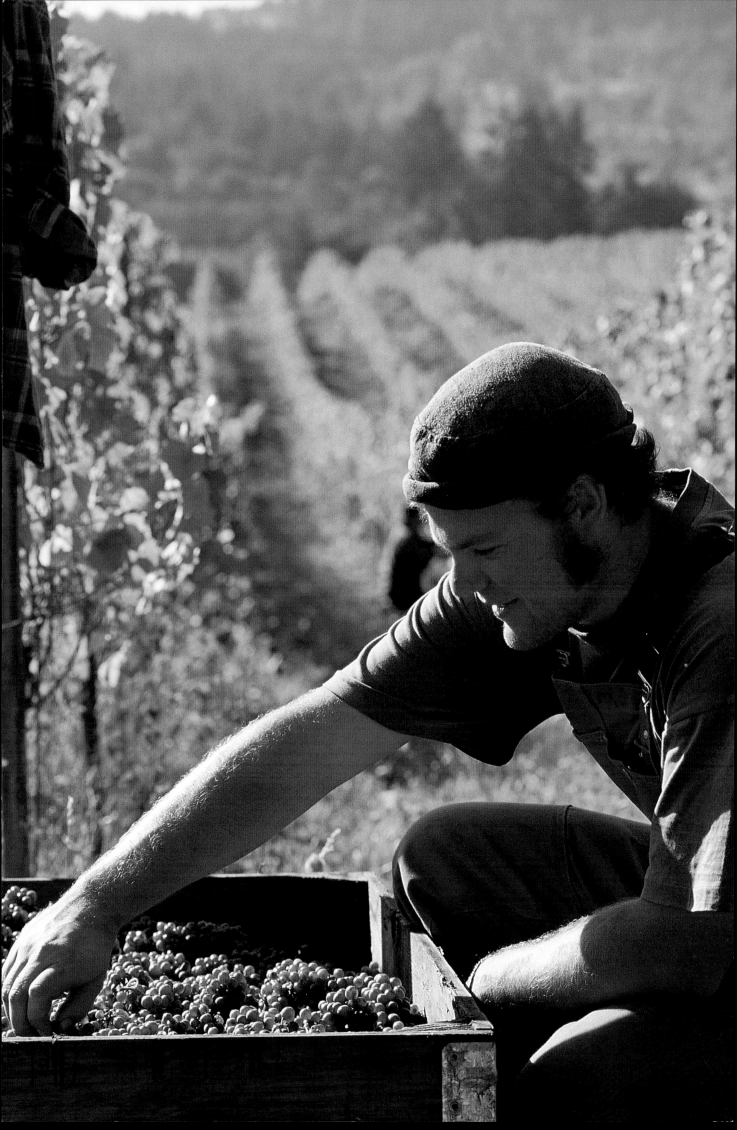

WINES
Pinot Noir
Chardonnay
Merlot
Pinot Gris
Riesling
Gewurztraminer
Cabernet Sauvignon
Semillon
Pinot Blanc
Mélon

Oregon the grape-growing entity was planted to specific European grape varieties *(Vitis vinifera)* for specific reasons—unlike the majority of the world's winegrape-producing regions. In Europe, it took several hundred years for regions such as Champagne, Burgundy, Bordeaux, the Mosel, Alsace, and Chianti to find their destiny. It was hit-and-miss. The Romans plunked down plants on their journeys through what are now significant wine regions. What remains dominant in these regions today are the varieties that made the most interesting wines for that region's climate.

This hit-and-miss practice was also prevalent in California. Thirty years ago Riesling was planted next to Cabernet Sauvignon next to Chardonnay next to Sauvignon Blanc. Only in recent years—in most cases, more recent than Oregon—have California grape growers replanted vineyards to more suitable varieties after taking the time to seek out the microclimates that will produce the best wines from a specific grape.

With its somewhat ungenerous climate, Oregon did not allow that luxury. Grape growers in Oregon, unlike their counterparts in warmer climates, had to locate the sites where grapes could ripen successfully in most years. Thus, Oregon is one of the few wine-producing regions where grapes were matched to the climate, and in many cases to the microclimate.

Oregon's cool climate is a mixed blessing. Although in rainy years it causes frustration, the cool climate is the most important reason people are growing winegrapes here. The forty-fifth parallel that bisects Oregon also passes through the great European wine regions. Oregon and these European grape-growing regions have in common a temperate climate in which the noble grape varieties ripen gradually, achieving perfect ripeness at the end of the growing season.

DAVID LETT
The Eyrie Vineyards

An only child reared on the out-skirts of Salt Lake City, David Lett knew from his earliest days that he was supposed to be a doctor. The problem was that he majored in philosophy and was not accepted into a medical school. While driving to California to check out a dental school, Lett discovered the Napa Valley and wine. Dental school was abandoned in lieu of a viticulture degree from the University of California at Davis. While there, Lett tasted his first Pinot Noir—a magnificent French Burgundy. He learned winemaking from Lee Stewart at the now-defunct Souvrain Winery, then embarked on a nine-month tour and apprenticeship in Europe. He came back convinced that California was not the best place to pursue his love affair with Pinot Noir; in 1965 he moved to Oregon. The Eyrie Vineyards celebrated its first crush in 1970. Since then, it has produced some lovely wines—indeed, some of Oregon's best. Lett also was the winemaker responsible for bring-ing Pinot Gris to Oregon.

The Eyrie Vineyards

Because of the earth's tilt during the summer months, days are actually longer along the forty-fifth parallel than they are farther south. Long, not-too-hot summer days and cool nights ripen grapes slowly and evenly. The sharp drop in temperature during the nights enhances acidity in the fruit. Grapes grown in cooler regions produce crisp, enticingly flavored wines. The world's greatest winegrowing regions are those in which the grapevines have to struggle. It is in cool climates, where ripening is marginal and vintages are variable, that the best, most complex wines are made.

Winegrapes grown in warm climates tend to be low in acid, with none of the distinctiveness and com-plexity that mark a great wine. "Everywhere I went [in Europe] I asked the same question, 'Why are these grapes planted here?'" says David Lett, the man respon-sible for bringing Pinot Noir to Oregon. "And I always got the same answer: 'Tradition!' Now, if you look at the total picture, it's obvious. There was an evolution based on quality. A thousand years ago everything was planted everywhere. I'm certain Pinot Noir was planted in Bordeaux and didn't do well because it was too warm. The pinnacles of wine quality always come from grapes grown in marginal climates."

Pinot Noir

Pinot Noir always has been the rarest of the noble grape varieties. Where one could safely point to 150,000 to 200,000 total acres worldwide for the other noble varieties—Riesling, Chardonnay, and Cabernet Sauvignon—total planting of Pinot Noir is thought to be closer to 40,000 acres, most of it in Burgundy.

Of all the grape varieties, Pinot Noir makes the most sensual wine. Noted British wine authority Jancis Robinson describes it as "a passionate wine—a wine of pure pleasure and hedonism, engaging all the senses ... it is a wine we can wallow in." Unlike its

Inset: Cluster primordia. *Right:* Pinot Noir grapes from this vine-yard—The Eyrie Vineyards' South Block—made a vintage 1975 wine that created international interest in Oregon Pinot Noir.

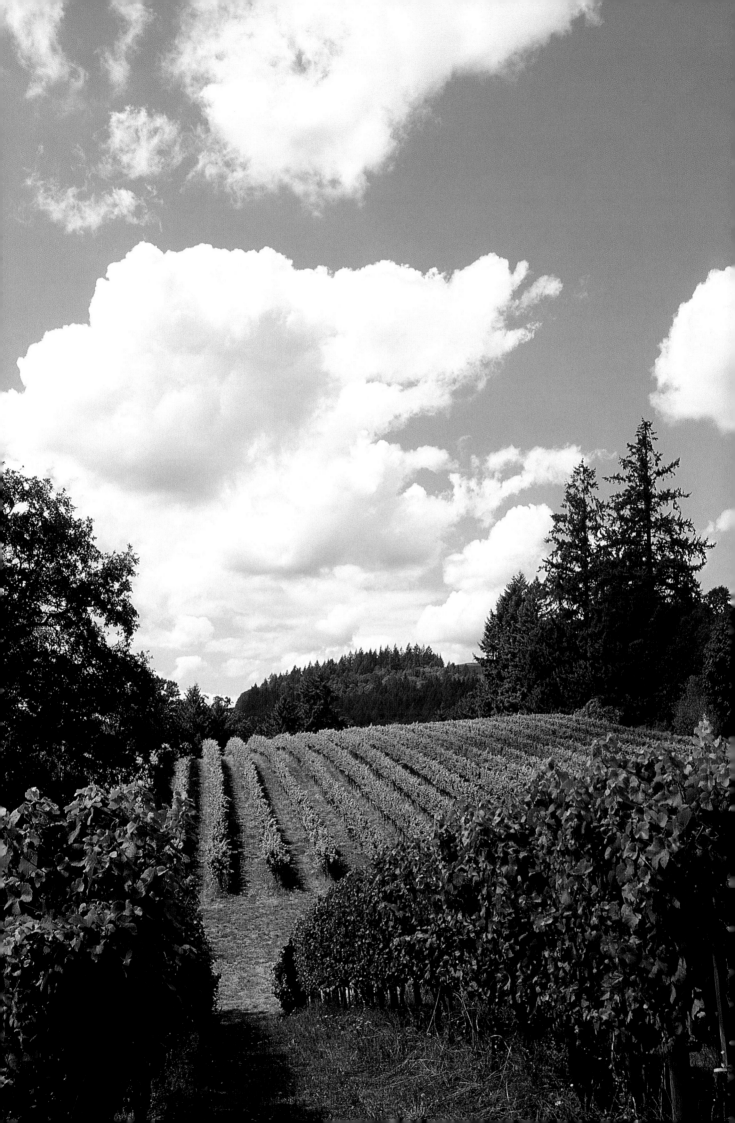

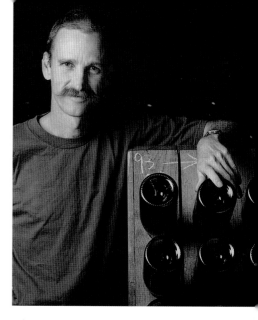

ROLLIN SOLES
Argyle Winery

noble red cousin, Cabernet Sauvignon, good Pinot Noir is approachable in its youth—perky with youthful fruit, sassy with acidity, refreshing, and easy to drink. As it ages, it takes on a smoky, silky quality. Enjoying a mature Pinot Noir from a fine vintage is one of wine appreciation's greatest rewards. It elevates mere tasting to a sensual realm. It is what the wine fuss is all about.

Compared to other red wines, Pinot Noir is generally medium in body, rather than heavy, with a clear garnet red color. Aromas and flavors run the gamut from the tart berry to the deep, ripe stone fruits such as cherry and plum. Normally aged in French oak, it displays nuances of oak—smoke, toast, cinnamon, clove, pepper. The flavors and aromas are complex and enticing.

And the wine is among the most food friendly, complementing everything from salmon to chicken to ripe, aged cheese, wild mushrooms, nuts, lamb, a lovely steak. Chefs have been known to go crazy with Pinot Noir, putting aside the tried and true smoked salmon, wild mushroom soup, or duck breast salad for something more adventuresome—perhaps a chilled avocado soup with mango and red chili salsa, or a sweet potato torta with smoked cheese wrapped in a flour tortilla—as one chef did to great accolades several years ago at the International Pinot Noir Celebration in McMinnville.

Thirty years ago, fewer than ten acres of Pinot Noir were planted in the state. In 1996 Oregon had just under three thousand acres of Pinot Noir, making it the most-planted variety in the state. While wine writers may wax eloquent about the mysteries of Pinot Noir, the true mystique of this grape variety is the economic factor known as supply and demand. Good Pinot Noir is dear, and the value of this elusive red varietal is inextricably linked to its short supply.

Why supply is short has to do with climate. To yield a quality red wine, Pinot Noir tolerates a narrower climatic range than the other noble varieties.

A native of Fort Worth, Texas, Rollin Soles is a graduate of Texas A&M. As a died-in-the-wool Aggie, he made his first wines in—where else?—Texas. West Texas. But the wine bug bit him hard. He went on to get his master's degree in enology from the University of California at Davis, then worked in Australia for Petaluma Winery. It was there that he and Petaluma owner Brian Croser cooked up a crazy idea—making sparkling wine in the United States. Soles returned to California and began to research possible winery locations. He chose the northern Willamette Valley for its cool maritime climate. Soles has made Argyle wines since its first crush in 1987. His sparkling wines continue to be some of the best produced in the United States and were the first Oregon wines to be served at the White House.

◇ARGYLE◇

Inset: Smoked salmon. *Left:* Following rigorous and labor-intensive hand "riddling" and disgorging of the dead yeast cells, bottles of sparkling wine await labeling. Riddling is a process whereby dead yeast cells from a sparkling wine's secondary fermentation are shaken into the neck of the bottle.

61

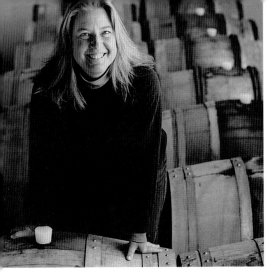

PATRICIA GREEN
Torii Mor Winery

Active in the Oregon wine industry since 1986, Patricia Green kept somewhat in the background, working as a consultant in production and marketing for Umpqua Valley's HillCrest Vineyard and Girardet Wine Cellars, among others. In 1993 she was approached by Don and Trisha Olson, owners of a mature and productive vineyard in the Dundee Hills. "The Olsons put a lot of faith in me," Green said. "Don asked me, 'Can you start a winery?'" She could and did. The winery is housed in what was formerly the Arterberry Winery in downtown McMinnville. Not glamorous, the simple facility "has allowed us to focus on the wine and find our style," Green said. The winery's tasting room is located at the vineyard. Torii Mor gets its unusual name from the Japanese gates at the vineyard's entrance.

The climate must be fairly cool for the variety to maintain its acid. The grape seems to gain complexity in a long, cool growing season and to develop ponderous flavors in a short, hot one. Thus a favorable climate is one where the grape ripens just at the end of the growing season.

With its long, mild growing seasons and generally dry autumns followed by mild, rainy winters, western Oregon has proved hospitable to Pinot Noir. Why Oregon does not have more Pinot Noir planted could be due to its topography. Oregon's best vineyard land does not lend itself to large-scale planting. Vineyards for the most part are small and individually owned. As in Burgundy, they are planted on south-facing hillsides to take advantage of solar exposure and air and water drainage. Every vineyard is potentially a different microclimate. Some suffer from frost while neighbors are not affected. Some ripen early while others malinger.

Talk to six different winemakers, and you will learn six different and equally valid ways to make Pinot Noir grapes into wine. Fermentation temperatures, yeast strains, clones in the vineyard, stem contact, whole berries versus crushed, punching down versus pumping over, filtering, fining, different types of cooperage—these are just some of the areas where there is no right or wrong.

In general, winemakers today agree that the more gently Pinot Noir is handled in the winery, the better the wine. And they all agree that, more than any other factor, climate is responsible for the quality of Oregon Pinot Noir.

Two other factors generally thought to influence the quality of Pinot Noir are crop level and age of vines. In Oregon, as in Burgundy, vines are pruned to keep the crop level at around three tons or less per acre. Many winemakers also attribute their better wines to older vines. Ten years ago, only a few vineyards fit into the mature—twelve years or older—category. At

Inset: Lab analysis by Sam Tannahill from Archery Summit Winery. *Right:* At Willamette Valley Vineyards, a cellar worker cleans one of the huge, insulated stainless steel tanks. The jacketing around the tanks provides temperature control for fermenting wines, which then may be chilled to stop fermentation. When white wines have finished fermenting and are stored in these tanks, they may be cooled to preserve freshness of flavors.

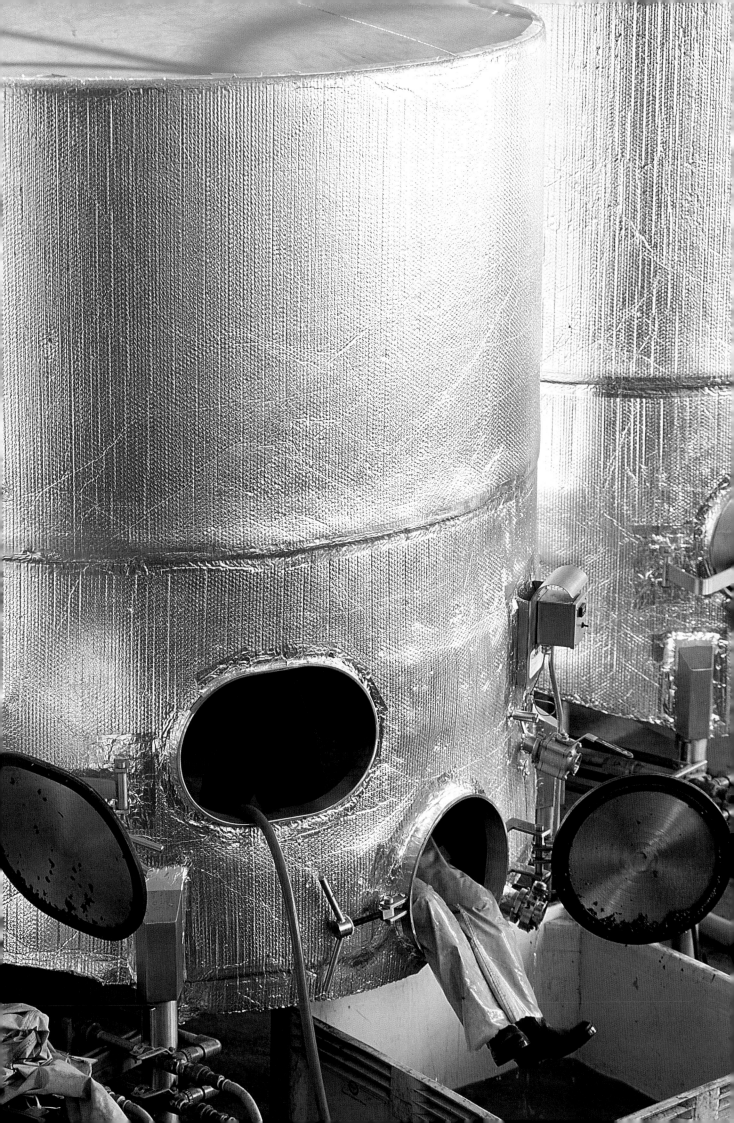

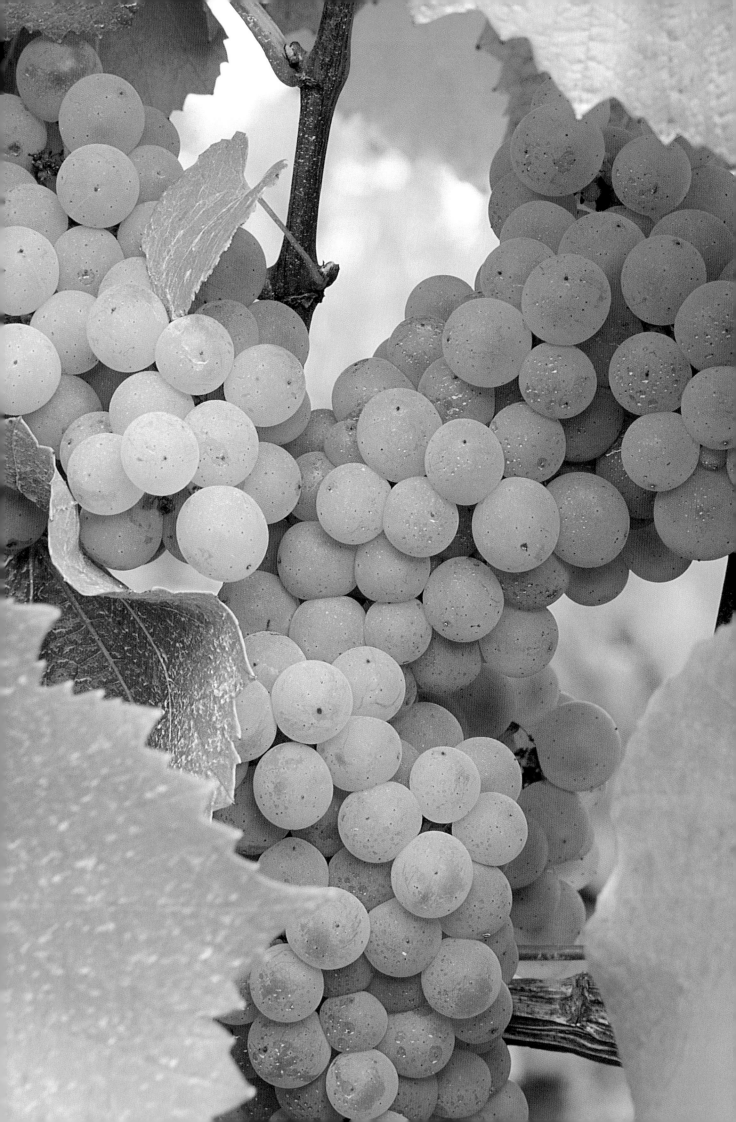

that time, most of the top Pinot Noir producers had access to older vineyards. In recent years, we have seen an overall improvement in the quality of Oregon Pinot Noir. The rainy autumns of 1995, 1996, and 1997 notwithstanding, progress continues to be made. Perhaps we have the older vines to thank.

Chardonnay

Chardonnay was one of the first European grape varieties planted in Oregon in the late 1960s. Like Pinot Noir, it is a grape that is now indigenous to the Burgundy region of France, so it should have been a great success in similarly cool western Oregon, right? Wrong.

The Chardonnay clones planted in Oregon in the late 1960s and into the 1990s are clones developed at the University of California at Davis. They were developed *for warmer climates*. They were genetically programmed to ripen later in the season. While Oregon Pinot Noir was fully mature and ready to pick at the exact end of the growing season, the California-developed Chardonnay clones grown in Oregon were not ripe until two weeks later. As a result, Chardonnay in Oregon often had to be picked before it reached optimum ripeness or got caught in end-of-season rains.

Winemakers struggled with the grape. In specific sites, such as Dick Erath's original vineyard on Chehalem Ridge and Bill Fuller's marvelous site in Washington County, Chardonnay was generally successful. Over the years, winemaking improved greatly, but the wines continued to be erratic.

Today the omnipresent Chardonnay is undergoing a revolution in Oregon. During recent years, Dijon clones from Burgundy made it through all the bureaucratic hoops, were propagated at test vineyards at Oregon State University, and are being planted throughout the Willamette Valley. Results are now reaching the market, and the verdict is that the new wines are different and, so far, significantly better.

It is a testimony to the skill of Oregon winemakers that Chardonnay has done as well as it has here. Currently, it is the second most-planted grape variety, with just over fifteen hundred acres.

Left: Clusters of juicy, almost-ripe Chardonnay grapes await picking. These later-ripening clones were developed in California. New clones coming from France ripen earlier, are naturally lower in acidity, and therefore are more suited to the Oregon climate.

DAVID ADELSHEIM
Adelsheim Vineyard

Visionary, scholar, and ambassador for Oregon wines, David Adelsheim of Adelsheim Vineyard, Newberg, long ago hung up his hat as just another small-time winemaker in another emerging viticultural area. In addition to founding what is now one of Oregon's leading wineries, Adelsheim was active in the industry well before his winery's first commercial harvest in 1978. As Dave and Ginny Adelsheim planted their vineyard in the early 1970s, Dave became known in the wine community for his efforts in education about Pinot Noir; his work with governmental bodies to write and revise Oregon's wine label regulations; his help in establishing Oregon's designated viticultural areas; and his research on the diverse clonal materials available from Europe. Adelsheim helped found the International Pinot Noir Celebration in 1987 and helped French wine producer Robert Drouhin purchase property in Oregon. Today Adelsheim serves on the board of the American Viticulture and Enology Research Network and lobbies at the national level for research funding for the Northwest's small fruit and grape industries. Don Kautzner took over winemaker duties for Adelsheim Vineyard in 1986; Adelsheim is now more involved in long-range planning, finance, promotion, and marketing. Adelsheim Vineyard is best known for its excellent Pinot Noirs.

HARRY PETERSON-NEDRY
Chehalem Winery

CHEHALEM

Raised on a farm in North Carolina, Harry Peterson-Nedry first tasted wine in his twenties. With a double major in Chemistry and English from the University of North Carolina, Peterson already was predisposed to a career that combines science and the arts. In 1980 the family purchased land on the Chehalem Ridge in Yamhill County. Planting began in 1982 with five acres of Pinot Noir. Peterson continued his career in industry, squeezing in grape growing and experimental winemaking during evenings and weekends. He formed The Chehalem Group Limited Partnership to allow vineyard expansion and additional land purchases, sold grapes to neighboring wineries, and in January 1993 released his first wine—Chehalem 1990 Pinot Noir. Bill and Cathy Stoller became partners, and the winery expanded in 1995 when Chehalem purchased Veritas Vineyard west of Newberg. In 1996 Peterson released Chehalem's first reserve Pinot Noir, the 1994 Rion Reserve, named after his friend and collaborator Patrice Rion, winemaker at Domaine Daniel Rion in Burgundy.

Pinot Gris

Oregon's other Pinot is lighter in color, but bears great resemblance to its cousin, Pinot Noir. Like Pinot Noir, Pinot Gris thrives in cool climates, yields somewhat stingily, and is remarkably food friendly.

Brought to Oregon in the mid-1960s by David Lett, the variety was virtually unknown to American consumers until recent years because it had not been grown commercially in California. Ironically, David Lett obtained his cuttings from test plots at the University of California at Davis and began making Pinot Gris commercially as early as 1970. But quantities were very small, and the variety only really took hold in the mid-1980s.

The grape is well known in Europe's cooler grape-growing areas. In the Alsace it also is called Tokay d'Alsace; in Italy, Pinot Grigio; in Germany, Rulander. In Burgundy, it may be called Pinot Gris, Auxerrois Gris, or Pinot Beurot. The latter term is for the color of the grape at harvest—a dark greyish, almost maroon that is the color of the habits worn by Burgundian monks in the Middle Ages.

The maroon Pinot Gris grape is made into a crisp white wine. The color of the wine ranges from a pale yellow green to a light gold. Aromas and flavors most often are of ripe pear, but can also hint at honeydew melon, banana, vanillin, and mineral. In Oregon, wines typically are sophisticated, fairly rich, dry, and crisp. Often Oregon Pinot Gris tastes like it has been aged in oak; however, this is not often the case.

Oregonians tend to make Pinot Gris more like the Alsatians. Whereas in Germany the wine is generally slightly sweet and in Italy very crisp and light, Oregon Pinot Gris at its best is rich, round, ripe, and full without being ponderous. Grapes generally reach full maturity of flavors at the end of the growing season, concurrent with or just before Pinot Noir. When grape sugars are high and the wine is fermented to dryness, the result can be a powerful yet elegant wine.

The variety gained in appeal with upper echelon Chardonnay drinkers who were looking for a different taste. With its richness tempered by lively acidity, Pinot Gris is remarkably food friendly. The most natural match for Pinot Gris in the Northwest is fresh

Right: In the aftermath of winter pruning, grapevines look significantly smaller. The previous year's wood is removed to make room for new growth. Discarded grapevine cuttings are a wonderful addition to the barbecue. Simply add to smoking briquets to flavor whatever is on the grill.

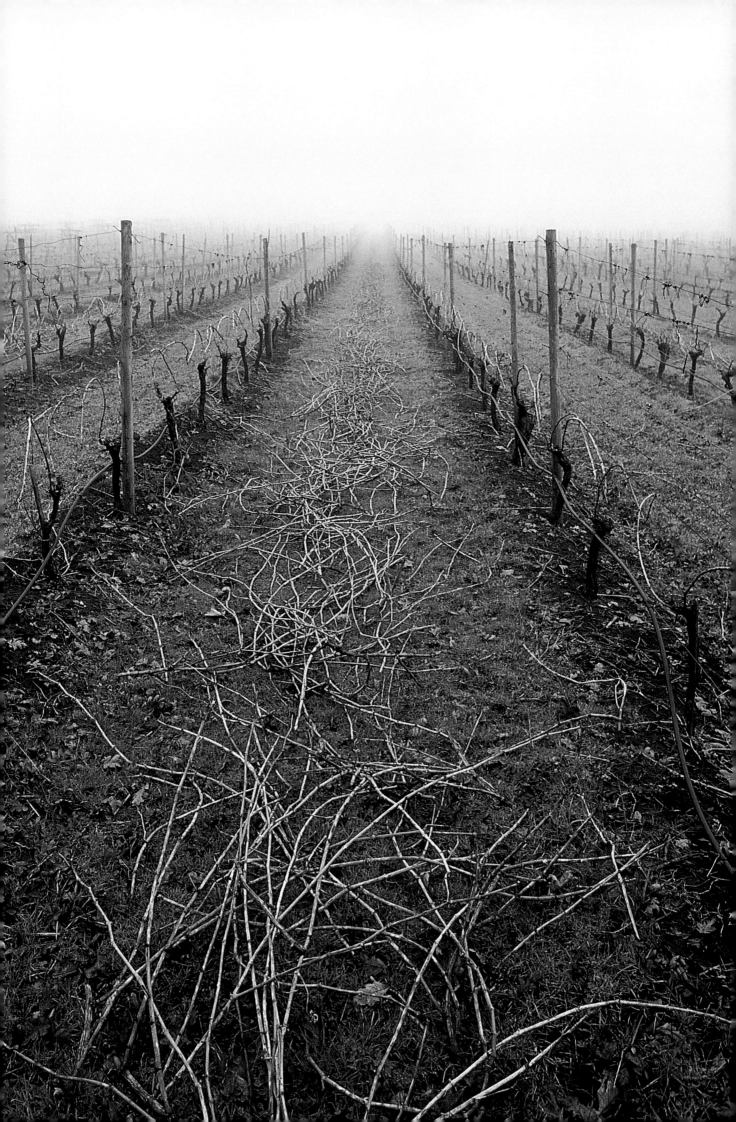

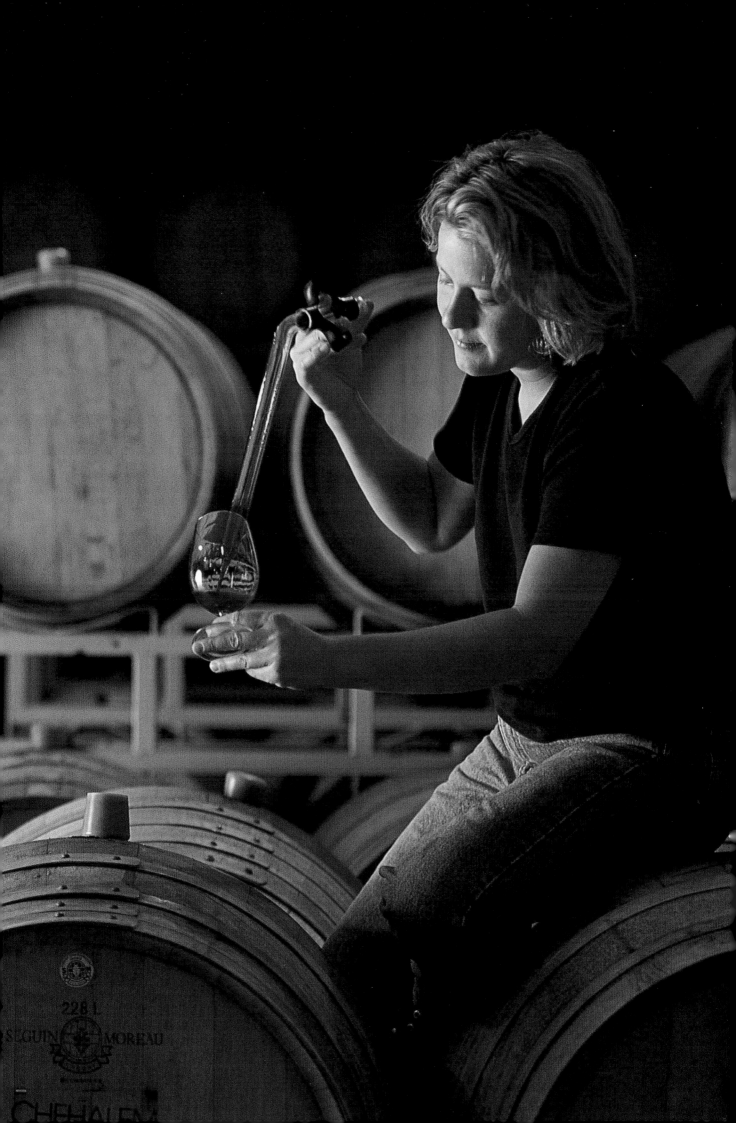

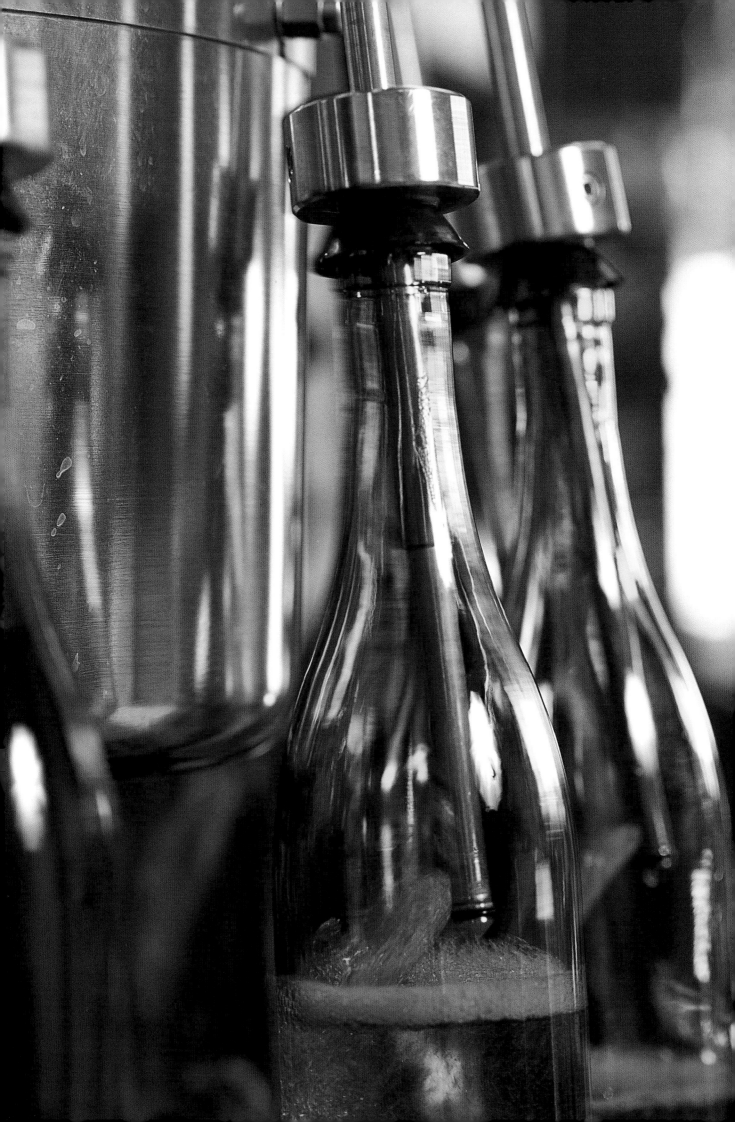

Pacific salmon. But to restrict it to salmon would be to do it an injustice. Pinot Gris wines are excellent with raw oysters, mussels, and Dungeness crab. Soups, other shellfish, mushrooms, pasta, *foie gras*, spicy grilled sausages, pork, Indian food, onion tart, and the traditional Alsatian *choucroute garni* (braised sauerkraut cooked in white wine with smoked pork, sausages, and vegetables) are just some of the foods compatible with Pinot Gris.

The variety ages well, too. In Alsace, those with access to older Pinot Gris drink the wines after they have been cellared for ten years. In Oregon, Pinot Gris produced by Ponzi Vineyards and The Eyrie Vineyards have demonstrated remarkable ageability. After five or six years in the cellar, these wines take on a velvety, buttery complexity and the toasty quality usually associated with oak aging. Don't be fooled. These luscious wines still have enough acidity to complement the foods listed above.

Because of the popularity of Pinot Gris in Oregon, several California vintners are now trying their luck with it. With more than a thousand acres in the ground, it is now one of Oregon's most planted varieties.

Riesling

Despite its promise, Riesling has been a nemesis to Oregon vintners. One of the four noble varieties, it was the one thought by Richard Sommer, Dick Erath, and others to have the most promise in this state. While Sommer has made occasionally brilliant wines with this grape under his HillCrest Vineyard label, overall successes have been few and far between.

The noble white Riesling grape is made into several different styles of wine. This has created a sense of confusion in the marketplace. The styles range from sophisticated, bone-dry food wines to unctuous dessert-style sippers. The problem is that these two extremes are fairly rare in Oregon, and the in-between styles are problematic. All too often, slightly to medium-sweet Rieslings have been made as cash-flow wines —quick-to-market slurpers made from overcropped grapes. They appeal to people who want a sweet-tasting wine that is fairly inexpensive. They are spurned by serious wine drinkers.

Pages 67-68: Cheryl Francis, co-winemaker at Chehalem Winery, graduated from Lewis and Clark College in biology. Here she samples Pinot Noir from a barrel, a process undertaken weekly in most wineries to ensure quality. *Left:* With its many checkpoints throughout the process, the modern bottling line, such as this one at Panther Creek Cellars, is now a quality measure employed by most Oregon wineries.

DICK & LUISA PONZI
Ponzi Vineyards

PONZI

Ponzi Vineyards, one of Oregon's earliest wineries, is now run almost entirely by the second generation. Dick and Nancy Ponzi came to Oregon from California. A first-generation Italian, Dick Ponzi had learned winemaking in his youth. The family settled in the Willamette Valley and began planting their vineyard near Beaverton in 1970. Their first vintage was in 1974. Winemaker Dick Ponzi gained a reputation early on for his fine Pinot Noir, Chardonnay, and dry Riesling. He was one of the first to make Pinot Gris. Today he and daughter Luisa also tinker with two Italian varietals, Arneis and Dolcetto. Luisa learned winemaking primarily from her father and from working in wineries in Italy. In recent years, her dad has increasingly relinquished responsibility in the winery so that today the winemaking title is hers. Dick's daughter Maria is in charge of marketing, and his son Michel directs and oversees vineyard operations.

STEVE DOERNER
Cristom Vineyards

California native Steve Doerner did not go looking for a career in the wine industry. Rather, it found him. Doerner majored in biochemistry at the University of California at Davis and says he was mildly curious about the wine industry when he was hired as a biochemist at Calera Wine Company in California in 1978. By 1980 Doerner was winemaker at Calera. But, he admits, "I didn't get it." Making wine was just a job until he visited Burgundy in 1981. There, steeped in the traditions of several hundred years and drinking fine Pinot Noirs, Doerner became passionate about winemaking. Back in the United States, Doerner's reputation grew as he crafted some of California's finest Pinots. Meanwhile, in Oregon, Pennsylvania natives Paul and Eileen Gerrie purchased a floundering winery in the Eola Hills. In 1992 they recruited Doerner as winemaker for their new venture, Cristom Vineyards. Doerner has thrived in Oregon, producing consistently delicious Pinot Noir, Chardonnay, and, more recently, Pinot Gris.

CRISTOM

A pity. This noble grape variety deserves better. In its youth, good Riesling wine is fresh, somewhat simple, and tart, with honeysuckle in the nose and a fresh green apple flavor. At its peak of maturity, what began as a fairly simple wine is shockingly complex, with the bouquet and flavors of herbs, summer fruits, and honey. The texture of the wine in the mouth is bracing, tart, and light early on, but matures to a velvety unctuousness. Crisp acids keep these fine wines interesting as they age.

In Germany, fine, off-dry to medium-sweet Rieslings are much sought in the good vintages. They are characteristically low in alcohol (nothing gets too ripe in Germany most years), crisp, with lovely aromas and flavors of apple or peach and jasmine. They have a mineral, almost steely quality that makes them an excellent foil for a vast range of foods. While this level of quality comes along rarely in western Oregon, over the years lovely renderings have come from Elk Cove Vineyards, Sokol Blosser Winery, Tualatin Vineyards, Shafer Vineyard Cellars, Willamette Valley Vineyards, Eola Hills Wine Cellars, Erath Vineyards Winery, and HillCrest Vineyard.

In France, the Alsace region arguably produces the finest Rieslings in the world. Bone-dry and fairly high in alcohol, they boast aromas and flavors of honey, grapefruit peel, and crisp apples. Powerful, spicy, complex—these wines complement the rich, spicy foods of the Alsace. Oregon wineries with a commitment to dry Riesling are Amity Vineyards and Ponzi Vineyards. Adelsheim Vineyard also once produced a lovely dry Riesling, and occasionally, brilliant efforts have come from Tualatin Vineyards and a smattering of others.

Late-harvest Rieslings—those affected with the "noble rot" *botrytis cinerea*—are quite rare in this part of the world. Only in years when the conditions are correct can the grapes hang extra weeks on the vine, their juices slowly concentrating in the cool, sunny days and crisp, damp nights. More often, in the Willamette Valley the grapes simply rot in the rain. But there have been the occasional gorgeous, late-harvest Rieslings from Elk Cove Vineyards, Montinore Vineyards, HillCrest Vineyard, Cameron Winery, Ponzi Vineyards, and Hinman Vineyards/Silvan Ridge

Right: Veraison—the French term for winegrapes turning color at season's end—occurs around Labor Day in most Oregon vineyards. Picking begins approximately thirty days after the color change occurs.

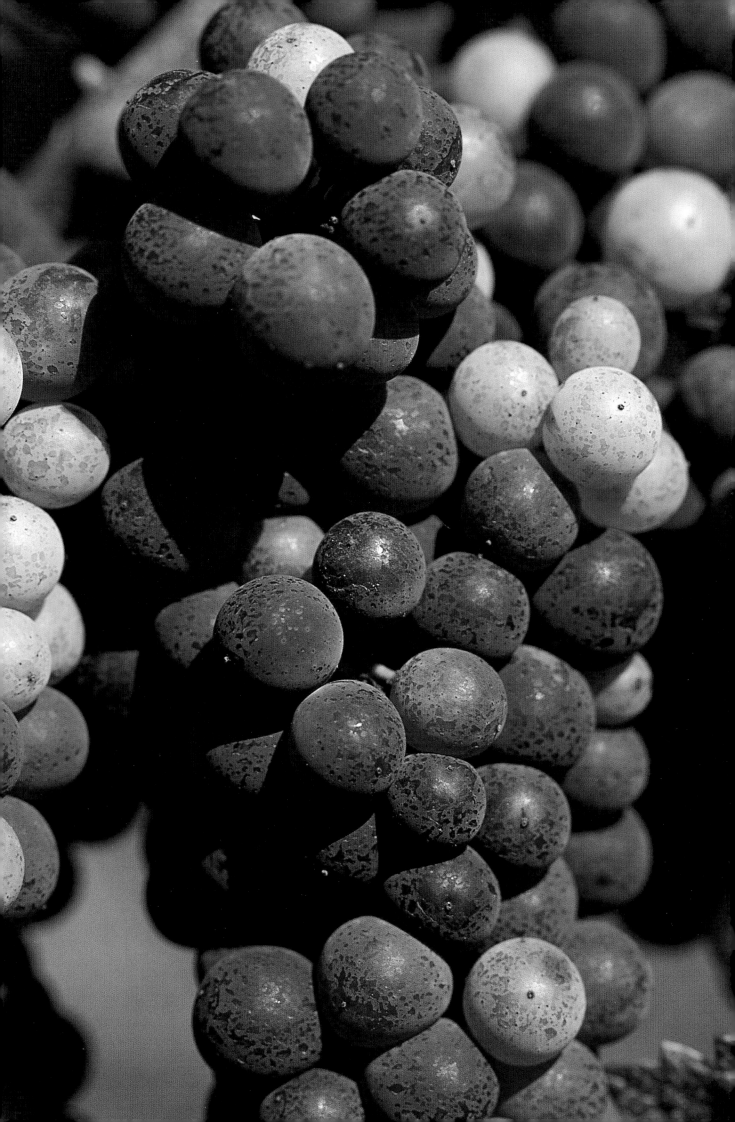

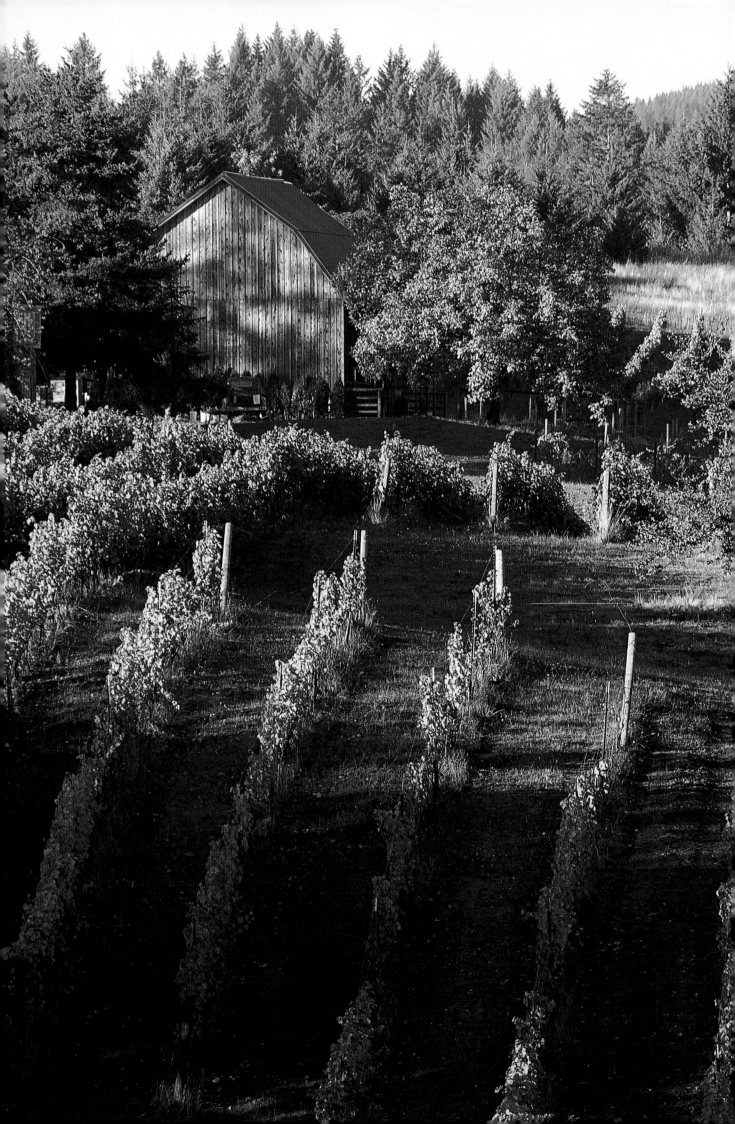

DOUG TUNNELL

Brick House Vineyards

—enough to capture the attention of Oregon wine-makers, who often wait patiently for the miracle and are only sometimes rewarded with such wines.

Today, Riesling is the fourth most planted variety. Many winemakers are cutting back on Riesling production or are grafting their vines over to something entirely different. What was once thought to be a sure thing turned out to be harder than it looked.

Enjoy dry Oregon Riesling with the Alsatian dish *choucroute garni*, shellfish, pork, poultry, trout, or any fatty fish with a fruit sauce. The off-dry/slightly sweet Rieslings complement a variety of cheeses. The better ones are delicious with pork or Thanksgiving turkey with all the trimmings and are enticing sippers, either alone or paired with summer fruits.

When a late-harvest Oregon Riesling is available, sip a little after dinner or pair it with a fruit dessert such as trifle, a fruit tart, or poached pears with a fruit sauce. As a general rule, the dessert should not be sweeter than the wine. More adventuresome diners will try a sweet Riesling with lobster bisque, Coquilles St. Jacques, or fresh Dungeness crab drizzled with melted butter.

BRICK·HOUSE

A relative newcomer to the Oregon wine scene, Doug Tunnell lived in Miami and spent seventeen years as a foreign correspondent for CBS television news. But the West Linn, Oregon, native always wanted to return to his home state and own property. In 1990 he bought a forty-acre farm on the Chehalem Ridge west of Newberg and began planting grapes. In 1992 Tunnell left CBS and moved to his Oregon farm. His first commercial harvest was in 1993. Today, with twenty-six acres of vineyard, Tunnell is a full-time grape grower and winemaker and has learned both jobs by doing them. Much of his winemaking advice comes from Steve Doerner of Cristom Vineyards. He produces Chardonnay and Pinot Noir and particularly enjoys experimenting with Gamay Noir.

Gewurztraminer

Like Riesling, Gewurztraminer was, at first glance, a natural for Oregon. Though not widely planted (less than two hundred acres in 1996), it held all the promise of Riesling. The climate seemed ideal. It is a grape that enjoys a cool climate, but the often wet, late springs in the northern Willamette Valley sometimes hurt the Gewurztraminer crop. And, like Riesling, it is a harder grape to work with than one would think. People who counted on it for cash flow were sorely disappointed.

Though slightly sweet Gewurztraminer is made in Germany, the best in the world comes from the Alsace where the grapes hang late into the season and produce powerful dry white wines. In Oregon the best Gewurztraminers are the dry ones. Amity Vineyards

Inset: Fall bounty. *Left:* The grapevines at Brick House Vineyards have been organically farmed since they were planted in 1990. The barn houses the winery.

and Tualatin Vineyards made Oregon's first dry Gewurztraminers. More recently, Tyee Wine Cellars, Henry Estate Winery, Bridgeview Vineyards, Foris Vineyards Winery, and Erath Vineyards Winery joined the ranks of those making reliably good dry Gewurz. In some fortunate vintages, Erath and Elk Cove Vineyards have made delicious late-harvest Gewurztraminer.

Pinot Blanc

Another relative of Pinot Noir, Pinot Blanc is the hottest new variety in Oregon. Actually, it has been here a while. David Lett has had a few plants for many years. Only in recent years has Pinot Blanc been produced as a variety. About a dozen Willamette Valley wineries currently make Pinot Blanc, and the wines are fabulous.

Early on the scene were Adelsheim Vineyard and Cameron Winery. They make the distinction between the Pinot Blanc grown in Oregon—which is the real thing—versus the wine called Pinot Blanc in California—which is some other type of grape but still makes a pleasant white wine.

To get consumers familiar with Pinot Blanc, its producers have gotten together and staged annual tastings. The wines show a difference in style, but overall are very fine indeed. Delicious Pinot Blancs are available from Bethel Heights Vineyard, Cameron Winery, Adelsheim Vineyard, WillaKenzie Estate, Amity Vineyards, and Erath Vineyards Winery, to name a handful.

Look for increased acreage, greater availability, and a good deal of publicity on this wonderful food-friendly wine.

Other Varieties

Of the other winegrape varieties planted in Oregon, the Bordelais varieties—Cabernet Sauvignon, Merlot, Sauvignon Blanc, and Semillon—account for the bulk of plantings. Most of these varieties are found in the Umpqua and Rogue appellations, the Columbia appellation near Hood River, and a smattering in the Oregon portion of the Walla Walla appellation. Bits of Zinfandel dot the warmest microclimates, and in the

Right: Just-harvested Pinot Noir grapes are dumped into the crusher-stemmer at Montinore Vineyards. Stems are removed as the grapes are gently crushed; then the grapes are put into fermentation vats. In some instances, winemakers return a portion of the stems to the fermenting grapes, thus adding certain flavor components to the resulting wines.

MARK WISNOVSKY
Valley View Vineyard

Unlike most Oregon vintners, Mark Wisnovsky grew up in the Oregon wine industry. He was a small boy when his family moved to Oregon in 1972 and began planting winegrapes at the site that had been homesteaded by Peter Britt in the 1850s. Valley View made its first wine in 1976. Today Mark and his brother Mike manage Valley View Vineyard. In addition to the Valley View label, since 1990 the winery's top wines have been bottled under a separate label, Anna Maria, named to honor their mother, Ann Wisnovsky. In 1985 the Wisnovskys hired John Guerrero, a graduate of the University of California at Davis, as Valley View's winemaker.

VALLEY VIEW VINEYARD

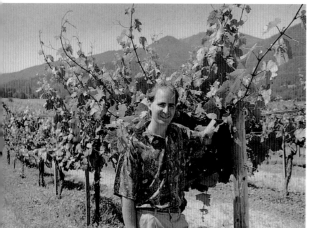

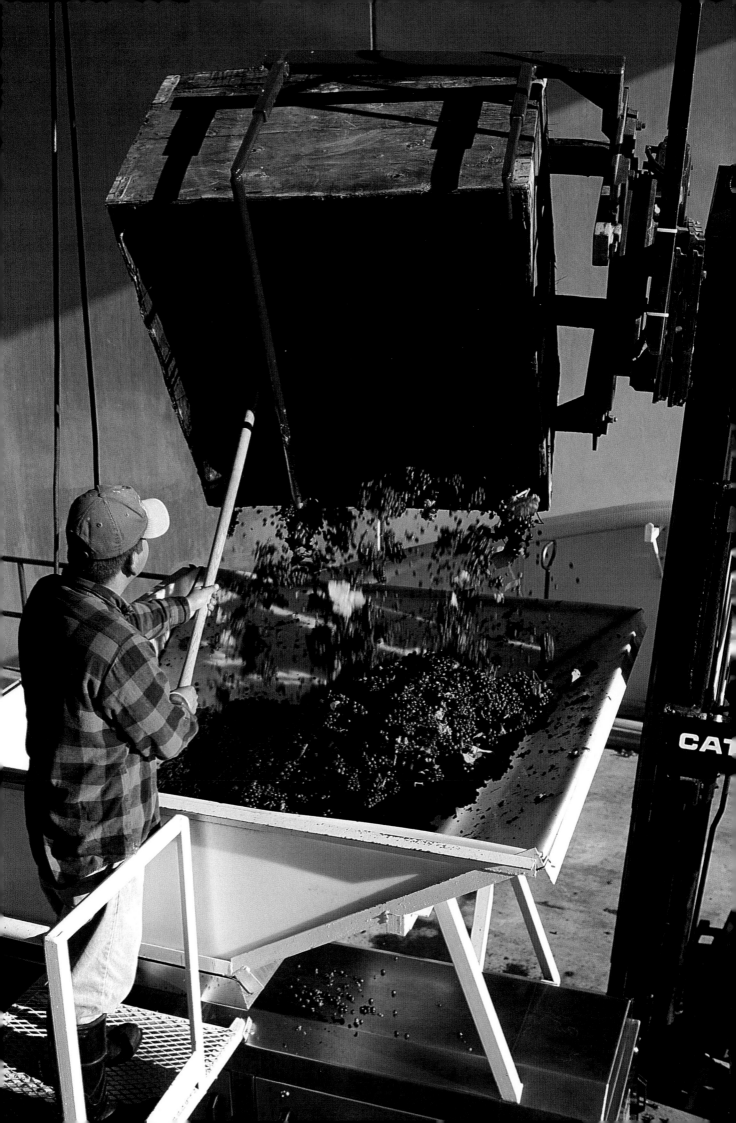

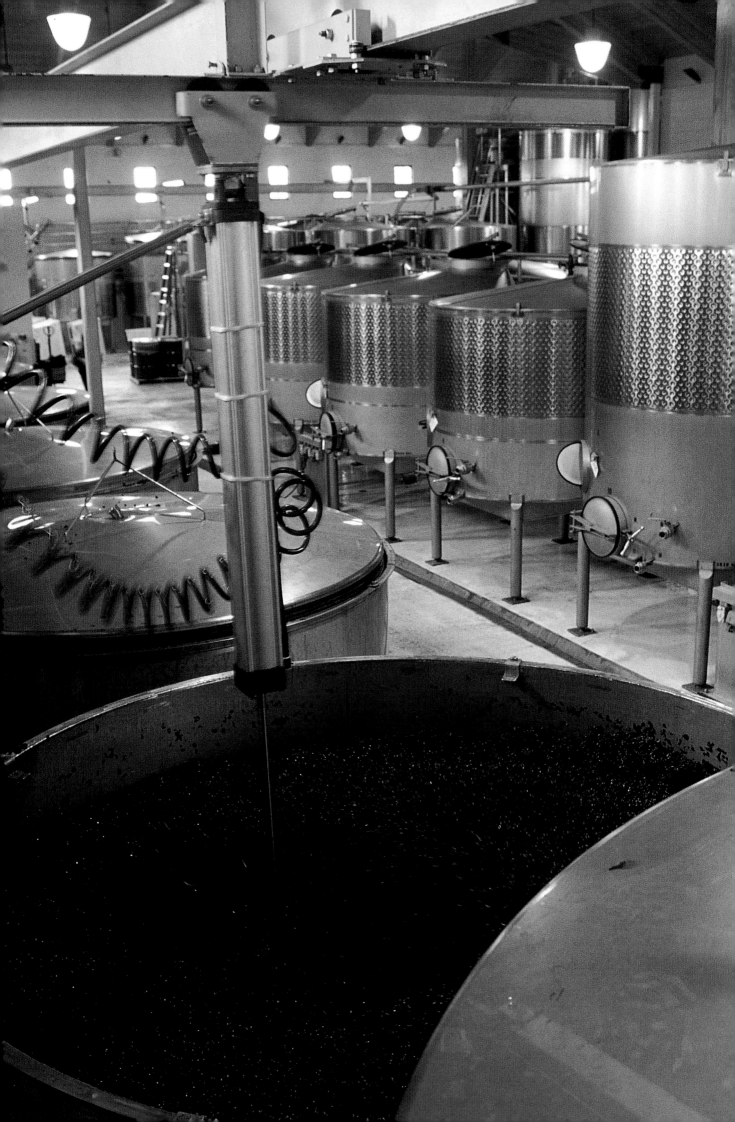

Willamette Valley about ninety acres have been planted to Muller-Thurgau. This minor variety from Germany bears generously and yields a delightful summer quaffing wine under ideal circumstances. A goodly portion of the crop, however, produces inexpensive, rather insipid wines.

Delicious Cabernet Sauvignon, Merlot, and blends of the two are made from southern Oregon fruit. The same is true of Sauvignon Blanc and Semillon (although in Oregon, Semillon is rare and is more often blended with Sauvignon Blanc). Notable are the Bordelais-style wines from Valley View Winery near Jacksonville. Foris Vineyards Winery in the Illinois Valley produces a reliably lovely Merlot. Girardet Wine Cellars, Ashland Vineyards and Winery, Bridgeview Vineyards, and Weisinger's of Ashland release very competent Cabernet Sauvignons.

The best Zinfandel in Oregon is made by a small producer in Newberg. Sineann Vineyard currently produces about one hundred cases of Zinfandel a year from Hood River–area grapes. The winery is owned by Peter Rosback. His Irish heritage led him to choose this intriguing name that, in the ancient Gaelic language, means "princess of the little people." His Zinfandel wines are produced at Chehalem Winery.

Dick Erath and Dick Ponzi currently are playing with two Italian varieties. The first is Arneis, which makes a luscious, viscous white wine in its native Peidmont district of northern Italy. It was resurrected from the dead there several years ago by Angelo Gaya and caught on like wildfire. It is very similar to good Oregon Pinot Gris in terms of its food friendliness and general character. It is too early to tell what it might do here, but the prognosis is good. The other wine of Italian origin is Dolcetto, which makes a light, spicy, playful red wine delicious for everyday drinking. Erath and Ponzi have experimented in small quantities with good results.

Thus far, nothing has been said about sparkling wine. Of all the wine-producing regions in the world outside of the Champagne district in France, Oregon is thought by many experts to have the most potential for making world-class sparkling wines. But sparkling wine can be made from a number of different grape

Left: At King Estate, tanks of fermenting Pinot Noir are punched down by machine. In the process, the cap of grape skins is pushed down into the fermenting juice to keep the cap moist and extract flavors from the skins. In smaller wineries, this is often done by hand with wooden paddles.

BARNEY WATSON
Tyee Wine Cellars

Barney Watson was studying biochemistry at the University of California at Berkeley when an advisor told him about the enology program at the University of California at Davis. "I was a nerd with horn-rimmed glasses," said Watson. "By my senior year I was fermenting things and blowing them up in the closet!" He took a break from academia to work two years in Alaska, then enrolled in the master's in enology and viticulture program at Davis in 1972. It took three years to finish the program because Watson, impassioned with winemaking and viticulture, worked summers and falls at wineries in Napa and Sonoma. While at Davis, he met several pioneer Oregon winemakers who visited the campus to give seminars on grape growing in Oregon. He was intrigued, even though the viticulture professors at Davis thought the Oregonians were crazy for planting so far north. In 1976 Watson was hired by Oregon State University as a research assistant in the Food Science and Technology program. "When I came here there were twelve wineries," he said. "I grew up with the industry." But it took him ten years to get his own winery. Tyee Wine Cellars is owned by Watson, his wife Nola Mosier, and Dave and Margy Buchanan. The small, specialty winery produces excellent Pinot Gris, Pinot Noir, and Alsatian-style dry Gewurztraminer.

TYEE
WINE CELLARS

varieties. In Champagne, it is made from Pinot Noir, Pinot Meunier, and/or Chardonnay. In Italy, it is made from the Muscat grape. In some parts of the world (including Idaho and Washington) sparkling wine is made from Riesling.

In Oregon it is made primarily from Pinot Noir and Chardonnay. Optimum flavors in winegrapes occur at two stages. The earlier is when the grape has achieved approximately 17 percent sugar. While grape flavors are delicious, the grapes do not yet have enough sugar to produce a still wine of adequate alcohol. The latter stage is at around 22 to 24 percent sugar. And this is when most grapes for still wines are harvested. Sparkling wine, by nature, is lighter, leaner, and lower in alcohol. High natural acidity gives a good Champagne its memorable, tangy freshness.

The same positive attributes found in grapes grown in Champagne also are found in Oregon Pinot Noir and Chardonnay grapes harvested at their earlier stages of mature flavor development. Argyle-The Dundee Wine Company produces some of the classiest dry sparkling wine made in the United States. Other Oregon wineries also have had formidable successes, but in much smaller quantities. The market for domestically made sparkling wine rises and falls. The process of making top-quality sparkling wine is slow, painstaking, and very expensive. But based purely on potential, where sparkling wine is concerned, Oregon has it all.

Right: A dormant vineyard in winter is shown prior to pruning. The vines are pruned yearly during December through February. The type and degree of pruning plays a significant role in determining the next season's crop level.

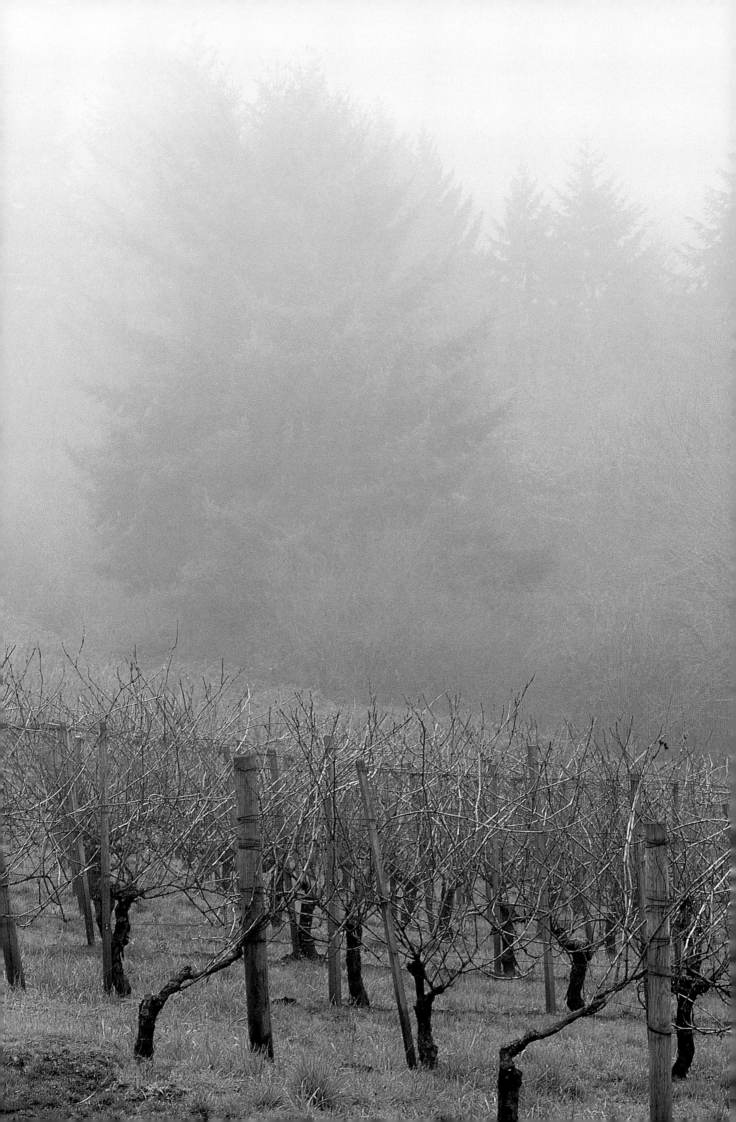

VINEYARDS
and
WINERIES

Diana Lett has seen it all, and she often has plenty to say about what she has seen. Her summary of the history of Oregon wineries, delivered to the author in 1989, goes something like this: "The Oregon wine industry has progressed in three stages—the dirt-ball idealists who fought the odds to prove a point; the later idealists who saw that it could be done and joined the old guard; and the MBA [Master of Business Administration] stage." The so-called MBA stage has come and gone, but new wineries are still popping up in Oregon. Many of the newcomers are still the small, family operations that have characterized the modern Oregon wine industry since its beginnings in the early 1960s. But there is a new generation emerging, too. It is comprised of the very rich and corporations.

So it is not surprising that an unlikely cast of characters is responsible for what is today's Oregon wine industry. They are the shy recluses, the technology dropouts, the back-to-the-landers, the restless romantics. They hitched their wagons to a dream, planted vineyards in rainstorms, harvested grapes in rainstorms, and slipped on lettuce in restaurant kitchens while proudly peddling their first vintages. They started with a whimper, not a bang. Ironically, most of them are still among us leading the comfortable lives of gentle farmers.

History at its most interesting may not be what people did at the time, but how they and others interpret it after the fact. The Oregon wine industry is a case in point. David Lett, looking back over the years, says it used to be more fun. Yet, the unexpurgated version of his and Diana's first summer at their Dundee Hills property is one of two adults with two small children in diapers, all living in a tent for a summer while the adults planted a vineyard. Fun? Perhaps for some.

RUSS & MARY RANEY
Evesham Wood Vineyards

"We met in St. Louis, Missouri, and moved to Oregon specifically to make wine," said Mary Raney, half the partnership of Evesham Wood Vineyards, Salem. When Russ and Mary Raney met, Russ had already developed a passion for wine. He majored in German in college and was studying German language and history in Germany when the wine bug bit him. During 1973 and 1974 he tasted in the Baden region and in nearby Alsace. *"I knew I wanted to do something with wine, but I didn't know what,"* he said. Raney apprenticed for two years at German wineries, then attended a German wine school. The Raneys purchased land in Oregon and planted their first grapes in 1986, the year of Evesham Wood's first vintage. They built a beautiful, Tudor-style house and winery on their property in the mid-1990s. Russ is winemaker; Mary runs the business side of the winery. Evesham Wood's specialty is Pinot Noir, but the Raneys also produce Chardonnay, Pinot Gris, and an excellent Gewurztraminer.

The Dirt-ball Idealists

The people who started vineyards and wineries in Oregon in the industry's first phase were fleeing the corporate world. When they came here, it was not to pursue chi-chi surroundings or lifestyles of the rich and famous, but rather to get back to the land and create what they envisioned as a better life for their families. And they came to plant Pinot Noir. "This is the only viticultural region in the United States where people planted grapes to match the climate rather than trying to make the climate match the grapes," David Lett once said, speaking for the pioneers.

"This is one of the last places in the world where someone not born into the wine industry can start a vineyard and winery," observed Nancy Ponzi. Most of the people who came here to plant grapes were inexperienced farmers. Few had any winemaking experience. They were people of average means—talented, smart, adaptable, but not rich. It is a miracle, but most of them are still in business today.

Pat and Joe Campbell, the founders of Elk Cove Vineyards, celebrated the tenth anniversary of their winery with a lovely sit-down dinner at Nick's Italian Cafe. After dinner, they showed slides of the planting of their vineyard early in the 1970s. They lived that summer in a camper trailer with several small children. Then there was Myron Redford's old trailer, perched on a hillside a couple miles from Amity. And the Ponzis, who lived in what is now part of their winery while they planted vineyards and built their home. There are many stories like these, but you get the picture. Dirt-ball? Well, not quite. But it was a little rough.

Our parents and grandparents always love to remind us that things were different then. In the case of Oregon's wine industry, they were. We all were younger then. But age and time notwithstanding, it is

Inset: Elk Cove Vineyards. *Right:* Home to many of Oregon's best-known vineyards, the densely planted Dundee Hills look more like Burgundy than does most of Oregon. This photo shows Archibald, Dundee Hills, and Weber vineyards, among others.

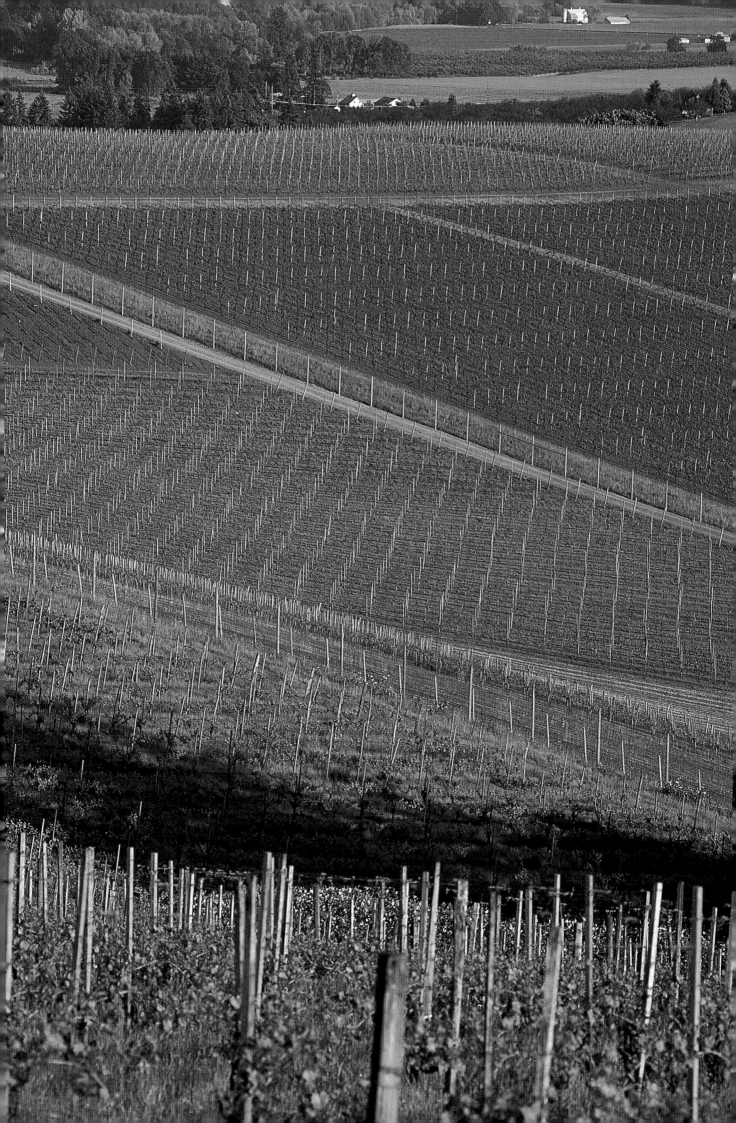

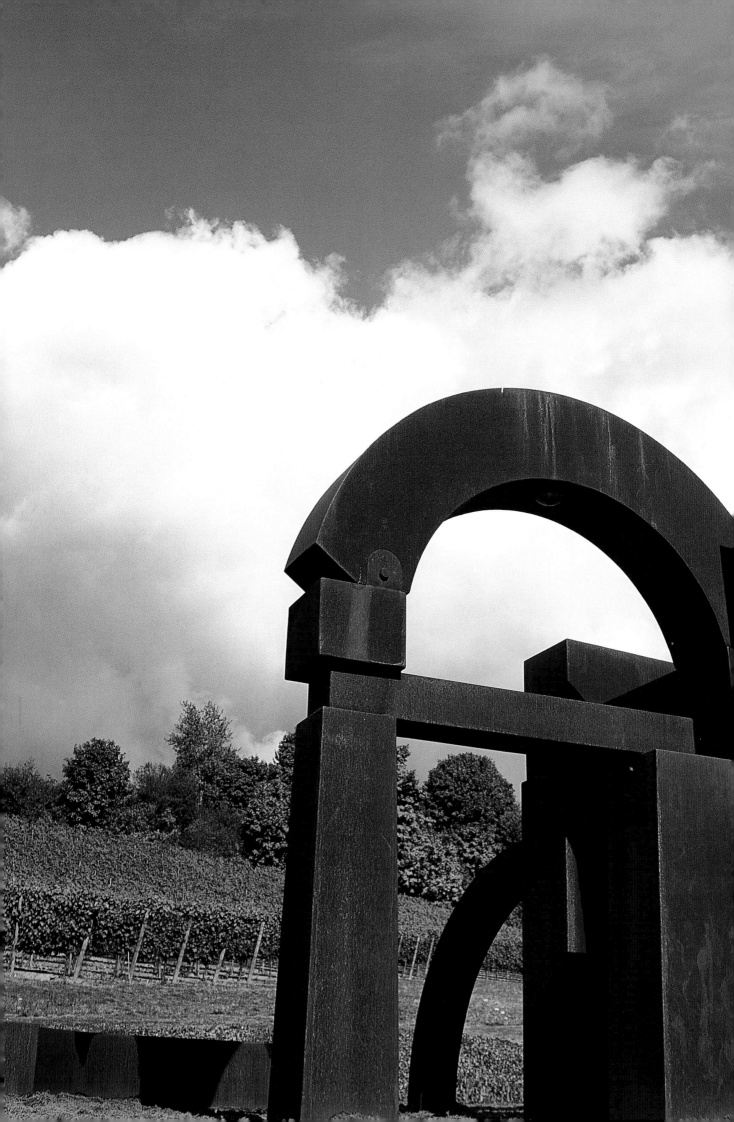

LYNN PENNER-ASH
Rex Hill Vineyards

difficult to picture anyone coming to Oregon to start a winery and doing things that way now. Things are different today.

Time has a way of softening the hardships. The pioneering environment was the norm for those who came to Oregon in the late 1960s and early 1970s. They found their twenty or forty acres, kept their day jobs, and planted their wine-grapes. Most Oregon vineyards were quite small in the early days. Many still are.

As recently as a few years ago, at what was the height of the California wine boom, an average family could move to Oregon, buy a few acres, and start their own vineyard with the eventual hope of opening a winery. This, no doubt, is what the Letts meant by fun. In California, during the past twenty years land prices have skyrocketed, and huge corporations have gobbled up one winery after another. The rest of the available vineyards and property have gone to the wealthy, because only the very wealthy can pay fifty thousand dollars an acre for land, care for vineyards, build a winery, and expect no reasonable return on their investment for ten years, if ever.

By way of contrast, in the late 1960s and early 1970s, Ma Bender made delicious fruit wines. The abundance of economical fruit enabled her to make good wines on a shoe-string budget. While the prejudice against fruit wines is nearly universal, there are still some great ones made in the Northwest. Honeywood Winery in Salem, Oregon, was established in 1934, making it the oldest premium winery in Oregon. Serious wine drinkers don't hear much about it because, until a few years ago, it produced only fruit and berry wines—some very good ones. Oak Knoll Winery, founded in 1970 near Hillsboro, made its name in fruit and berry wines: raspberry, loganberry, blackberry, rhubarb—some of the best of their kind any of us are ever likely to taste. Today, Oak Knoll is recognized for its barrel-fermented Chardonnay and Pinot Noir, as is Wasson Brothers Winery in Sandy.

When Lynn Penner-Ash assumed winemaker duties at Rex Hill Vineyards in June 1988, she was already a young woman with plenty of winemaking experience—in California. A University of California at Davis graduate in enology, Penner-Ash worked three crushes at Napa Valley's Domaine Chandon, sister winery to the prestigious French Champagne house Moet & Chandon, then spent four years as enologist for Stag's Leap Wine Cellars. Today, in addition to winemaking duties, Penner-Ash is president of Rex Hill Vineyards, which is owned by Paul Hart and Jan Jacobsen. Penner-Ash took to Oregon like the proverbial duck to water, transforming Rex Hill's sporadic success into consistently well-made wines in a range of prices.

Inset: Young plants are protected in cardboard boxes to keep wild rabbits from eating them. *Left:* Dramatic garden sculpture by Lee Kelly enhances the visitors' area and vineyard views at Rex Hill Vinyards and Winery near Newberg. The beautiful gardens and grounds at the winery set the scene for many festive summer events.

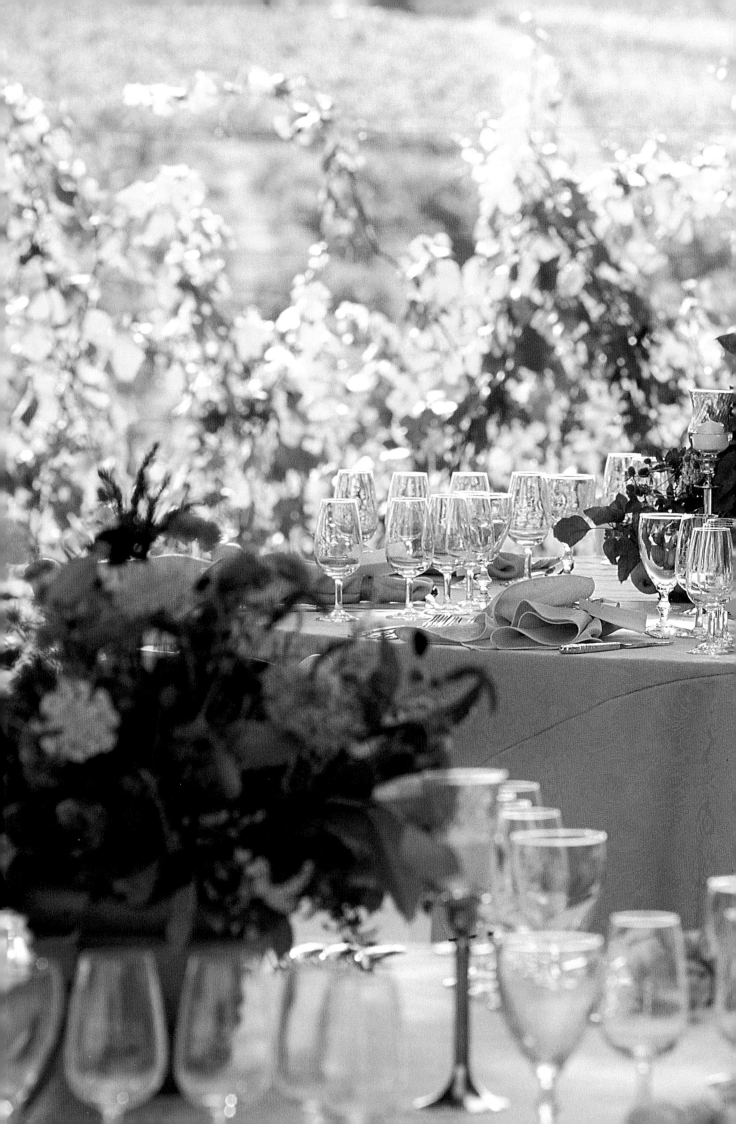

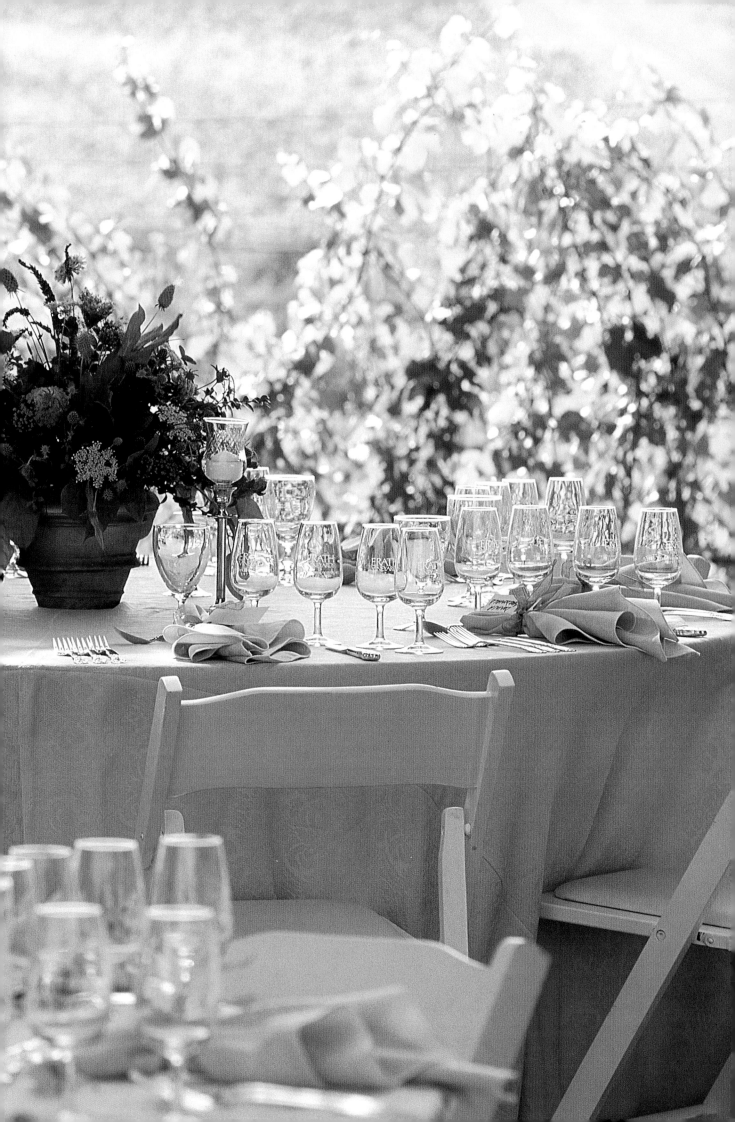

JACQUES TARDY
Montinore Vineyards

A Frenchman by birth, Jacques Tardy is fond of saying he grew up in the vineyards of Nuits-St.-Georges. His family's winery, Rene Tardy et Fils, has been in the family for many generations and is now run by his brother. With his brother destined to run the winery, Tardy came to the United States and worked for seven years as cellar master at the J. Lohr Winery in California before moving to Oregon. In 1990 he came to Montinore Vineyards as co-winemaker and has been winemaker since the 1992 harvest. Though he came to Oregon to make Pinot Noir, Tardy oversees production of many varieties at Montinore—and seems to be thriving. "You can be creative here," he says. "That's why I would never go back to France. There you are ruled by the government ... or grandpa."

MONTINORE
VINEYARDS

Oak Knoll and Wasson Brothers have taken home their share of gold medals, both for their fruit and berry wines and for their *vinifera* wines.

While fruit wines are currently out of fashion (liqueurs and fruit brandies are *in*), they are not to be despised. The Northwest's fruit and berries and its winegrapes are special for the same reasons. The growing season is perfect for all of them, with long, gently warm days and cool nights. Good sugars paired with high acidity translate into wines (fruit or grape) with interesting, refreshing, come-hither flavors.

The Second Generation

In the mid-1970s, a subtle shift came. This is when the first and second generations of Oregon vintners blur into each other. Where, for example, do the Fullers' and the Vuylstekes' and the Adelsheims' stories end and the Sokol Blossers' and the Wisnovskys' and the Shafers' begin? Nowhere. It is a continuum. The second generation learned from the first.

Bill Fuller began making wine in Oregon in 1973. As Tualatin Vineyards was being planted, Fuller, a winemaker from California, purchased grapes from vineyards in Washington. His neighbor, Harvey Shafer, began to plant vineyards in 1973 as well. For a time Shafer sold his grapes to Elk Cove Vineyards, but in 1979 he started making his own wine commercially under the Shafer Vineyard Cellars label. It was a great vintage to begin such a venture.

Bill and Susan Sokol Blosser started their Dundee Hills Vineyards in the early 1970s. A hobby, they said. When they decided to go commercial, they obtained investment capital from family members. Then they hired Portland architect John Storrs to design their winery, and Bob McRitchie, then chief chemist at Franciscan Winery in California, to make their wines. Like Fuller, the Blossers purchased most of their winegrapes from eastern Washington until their own vineyards were productive.

Inset: Tualatin Vineyards. *Pages 88 & 89:* Elegant high-summer table settings at Erath Vineyards herald the winery's twenty-fifth anniversary of its first harvest. *Right:* John Forbis, the farm's original owner, built the antebellum mansion at Montinore Vineyards in 1905. An attorney for the Anaconda copper mines, Forbis moved to Oregon at the turn of the century and specialized in legal affairs for Union Pacific Railroad. The name, Montinore, is a combination of Montana and Oregon.

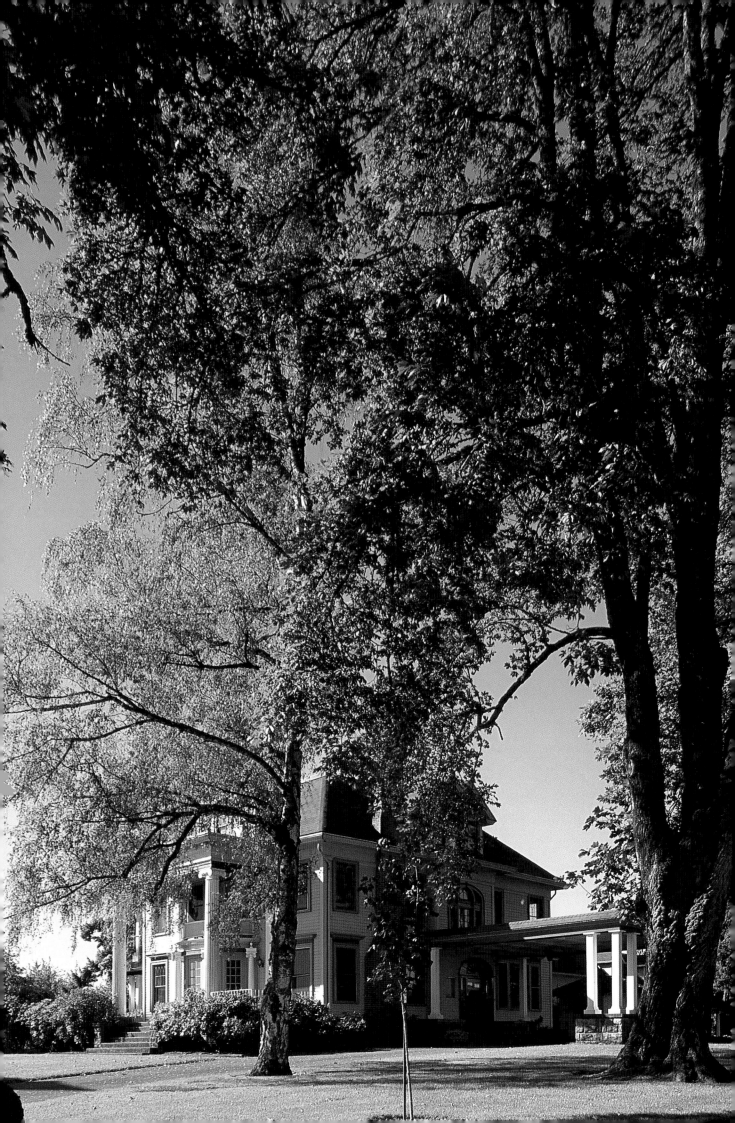

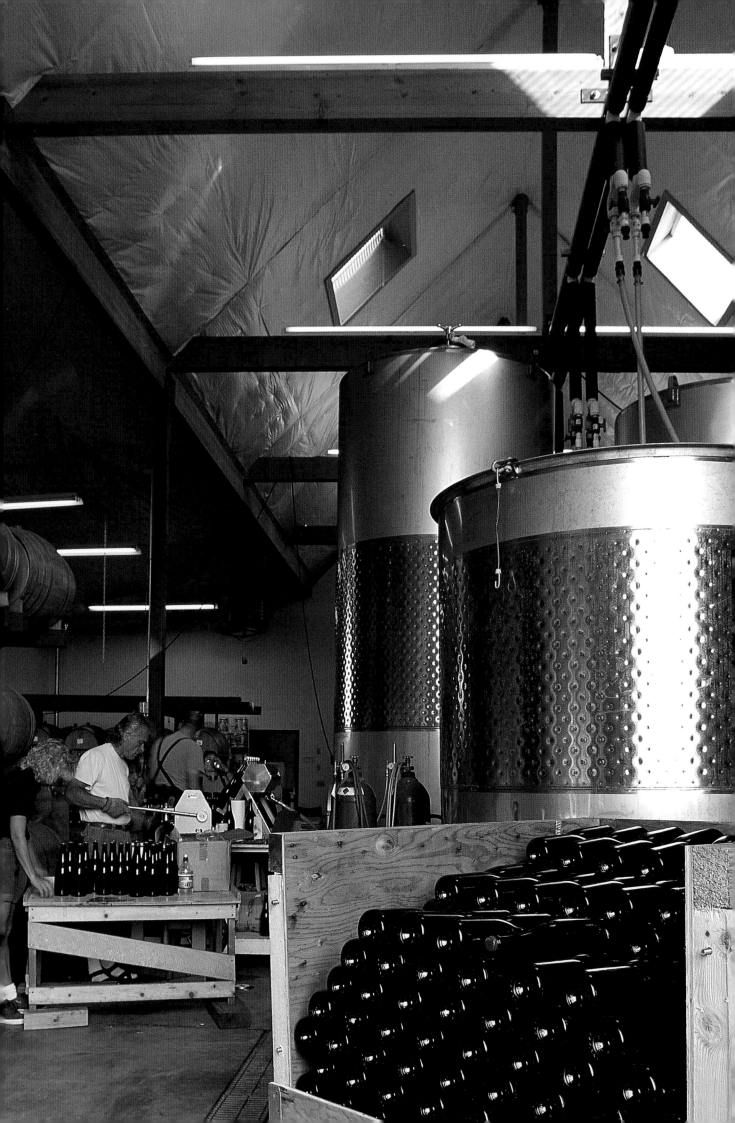

Other members of the second generation, Fred and Mary Benoit, pioneered near Eugene in the 1970s. They later moved their winery, Chateau Benoit, to Yamhill County "to be where the action is."

In 1971 the Wisnovsky family moved from New Jersey to a beautiful Wild West setting outside Jacksonville in southern Oregon and began to plant a vineyard. Today Valley View Winery is run by Mark and Mike Wisnovsky, who were small boys when their parents started planting. Historically, Valley View has produced many different types of wines, beginning in the 1850s when pioneer Peter Britt planted several grape varities on the property. Today Valley View's best efforts are Cabernet Sauvignon, Merlot, Sauvignon Blanc, and Chardonnay. John Guerrero, a University of California at Davis graduate, has been winemaker there since 1985.

Oregonian Scott Henry Jr. followed Richard Sommer's lead in the Umpqua Valley by planting a vineyard there in 1972. The difference is that Sommer planted his HillCrest Vineyard at the 850-foot elevation, while Henry planted his Henry Estate on the valley floor at the 400-foot level. Thus, Henry's site is considerably warmer than Sommer's. Henry, a graduate of Oregon State University, was a design engineer for the aerospace industry when he met Napa Valley winemaker Gino Zepponi, co-owner of ZD wines. When Henry decided to return to Oregon and plant grapes, Zepponi, by then a close friend, was his consultant. Henry made his first wines in 1978. The winery is known for its Pinot Noir, Chardonnay, and often superb Gewurztraminer.

The MBA Stage

It didn't have a lot to do with MBAs, but the third generation of Oregon's modern wine industry brought a decidedly different flavor to the mix. The boom came in the mid-1980s. But things were already in place for big changes in the Oregon wine scene.

MARK VLOSSAK
St. Innocent Winery &
Panther Creek Cellars

More than most winemakers his age, Wisconsin native Mark Vlossak grew up with fine wine and food. Beginning in 1959, his father began collecting wine and eventually imported fine wines. His mother trained with a French chef. The turning point in Vlossak's life was in 1982 when he read an article in Bon Appétit *about American sparkling wine. "Andre Tchelistcheff was quoted as saying Oregon would produce the best sparkling wine in America,"* Vlossak remembers. Inspired, he began to learn everything he could about wine through books, short courses at the University of California at Davis, and wine organizations. He wrote a prospectus and formed a corporation in 1988 to found St. Innocent Winery. He made wine that autumn in the former Arterberry facility in McMinnville and worked two harvests with the late Fred Arterberry Jr. before acquiring his own facility in 1989. In addition to running his own winery now in Salem, Vlossak is winemaker for Panther Creek Cellars in McMinnville.*

St INNOCENT

PANTHER CREEK

Inset: Chateau Benoit. *Left:* Workers at St. Innocent Winery place temporary caps on bottles of sparkling wine after a "dosage" (a sugar and water solution often flavored with brandy) is added to the wine to induce secondary fermentation. During this secondary fermentation, carbon dioxide bubbles are trapped in the bottle, providing the sparkle in the wines. The bottles will be riddled (shaken) and the dead yeast cells removed (disgorged) before the wine is permanently corked and readied for the market.

TERRY CASTEEL
Bethel Heights Vineyard

Terry Casteel is the winemaking partner of a family business; his twin brother, Ted, is vineyard manager; and his wife, Marilyn Webb, and sister-in-law, (Ted's wife) Pat Dudley, focus on business and marketing. The families bought an existing vineyard in 1978 and—with a commitment to excellent Pinot Noir, Chardonnay, and Pinot Blanc—have turned it into one of the state's best wineries. A former clinical psychologist, Terry Casteel learned by doing and from those more experienced in the wine community. He made experimental wines for several years while the families sold most of their grapes to other wineries. He produced Bethel Heights' first commercial wines in 1984.

Bethel Heights

In 1982 Leo and Jane Graham hired local business and economics consultant Jeffrey Lamy to do an evaluation of the farmland they had purchased near Forest Grove, Oregon, and determine how to make it profitable. Lamy was impressed with the Laurelwood and Cornelius soil types he found there and was convinced they would yield quality winegrapes. "All the Oregon Pinots that have drawn raves from respected wine authorities have been grown on these soil types or on Jory, which is a close relative to Laurelwood," he said.

Lamy spearheaded the planting of vineyards at the property, now known as Montinore Vineyards. In the meantime, the El Niño harvest of 1983 proved the best in history for Oregon's Pinot Noir growers. Fondly remembered as the El Niño Pinots, this group of 1983 Pinot Noirs baffled thirty wine experts assembled at the International Wine Center in the fall of 1985 to taste and evaluate Oregon and Burgundian Pinots. Not only could the tasters not identify which wines were from France and which were from Oregon in the blind tasting, but they also rated the Oregon wines higher. Another tasting was held in the winter of 1986 with the same result. The panel still rated Oregon wines higher overall and was unable to differentiate between French and Oregon. The wine media had a new darling.

Rex Hill Vineyards, Veritas Vineyard, and Yamhill Valley Vineyards were among those wineries that celebrated their first vintages in 1983 and whose wines scored highly in the New York tastings. It is interesting to note that grapes for these wines were provided by mature vineyards in the Willamette Valley. The Veritas and Yamhill Valley wines were made by Bob McRitchie, Sokol Blosser winemaker. Sokol Blosser Winery, The Eyrie Vineyards, and Adelsheim Vineyard also produced high-scoring Oregon Pinots.

In 1984, Cameron Winery and Bethel Heights Vineyard—two significant, quality producers on today's wine scene—made their first commercial wines. Then in rapid succession Evesham Wood Vineyards, Eola Hills Wine Cellars, Cooper Mountain Vineyards, Laurel Ridge Winery, Lange Winery,

Right: Bethel Heights Vineyard in the Eola Hills derives its name from the Bethel Hills named in 1846 by Reverend Burnett. One of the Eola Hills' earliest settlers, Reverend Burnett built his home half a mile from what is now the Bethel School. He named the hills to the east of his home Bethel after the church he left in his native Missouri. All of the grapes from the fifty-one-acre vineyard now go into Bethel Heights wines.

94

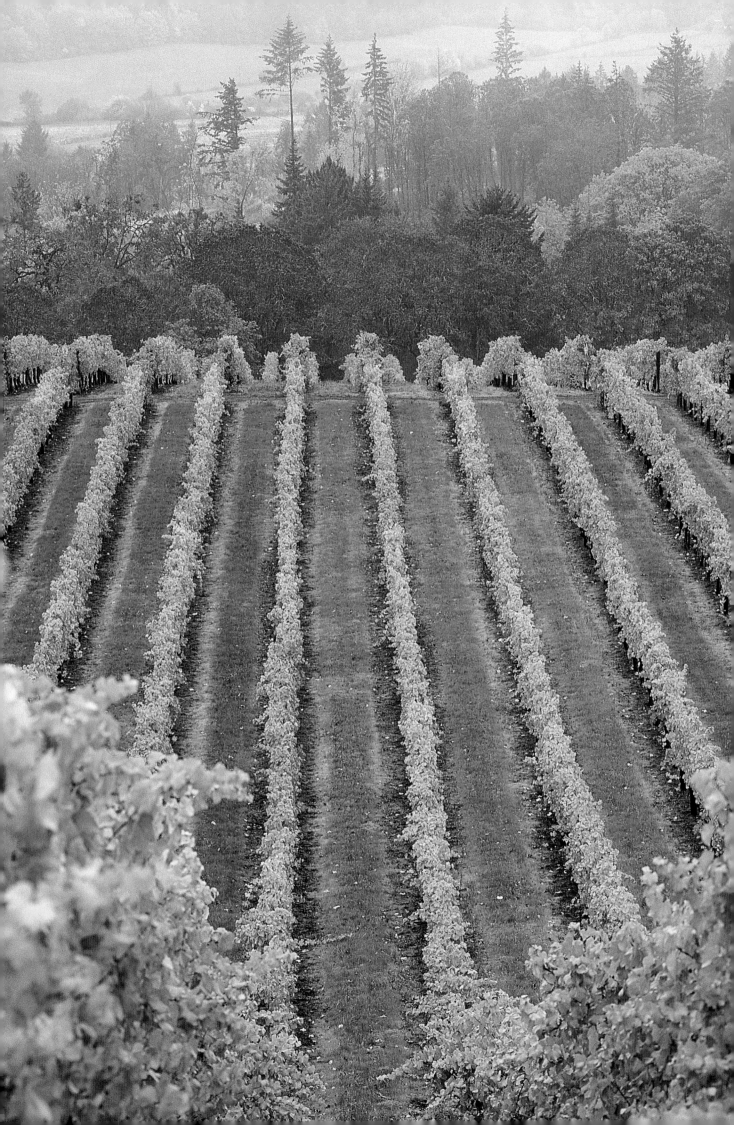

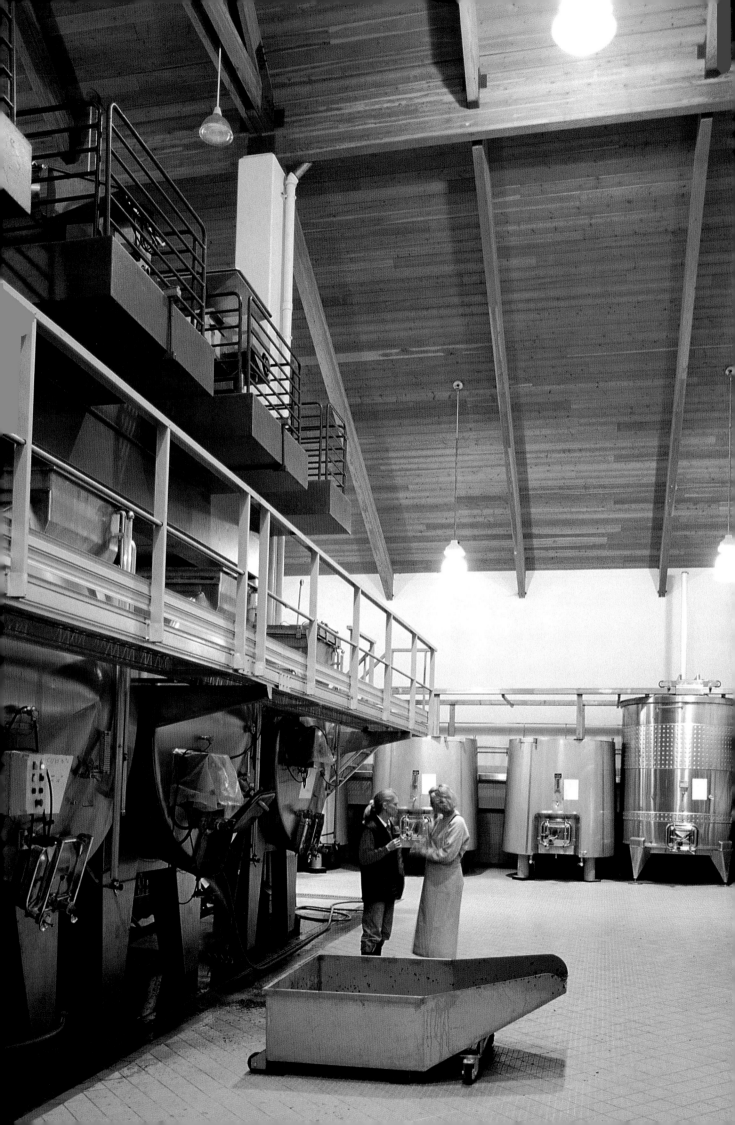

Autumn Wind Vineyard, Panther Creek Cellars, and several other wineries produced their first wines.

Montinore's first vintage was in 1987. Also during that banner year, Burgundian producer Robert Drouhin purchased vineyard land in the Dundee Hills. Winemaker Rollin Soles and Australian Brian Croser made Argyle Winery's first sparkling wines. Wine writer Robert M. Parker Jr. and his brother-in-law Michael Etzel purchased a vineyard site, now known as Beaux Frères, on Chehalem Ridge. This new wave of vintners had some of the down-home trappings of previous generations. But the combination of huge investors and international interest cast Oregon in an entirely new light. The stakes suddenly were higher.

The fact was not lost on people already in the industry. David and Diana Lett were among those who found the necessary dollars to purchase more land and plant additional winegrapes. Dick Erath and Cal Knudsen dissolved their partnership, forcing Erath to develop a new source of grapes (the vineyards surrounding Erath Vineyards Winery belong to Knudsen). Dick and Nancy Ponzi purchased a defunct vineyard site in Washington County, replanted it and called it Aurora Vineyard. The Adelsheims and others added to their vineyard holdings. Their faith in the Oregon industry was stronger than ever.

BIG

What to call the new kids on the block? In 1989 Diana Lett did not have a label. She—like the rest of us—could not predict with accuracy what would happen next.

Domaine Drouhin Oregon built a huge, beautiful new winery on their property in 1989. Even before the winery was completely finished, Drouhin's second crush was done there. It was the start of another, different wave of activity.

At the southern end of the Willamette Valley, Ed King III was working in Eugene when an idea germinated. His family had owned a broadcasting company in Kansas City, Missouri, and his father owned a

VERONIQUE DROUHIN
Domaine Drouhin Oregon

When Veronique Drouhin spent the 1986 crush working for three of Oregon's leading wineries, few suspected it was the precursor to the Burgundian wine dynasty's arrival in Oregon. Back in France, Veronique joined the winemaking staff at Maison Joseph Drouhin—and talked a lot about Oregon. By 1987 her father, Robert Drouhin, was convinced that, indeed, a venture in the United States looked promising. He purchased ninety-eight acres in the Dundee Hills and named Veronique as winemaker for the new winery early the following year. Planting at the site began in 1988. Veronique made her first Oregon Pinot Noir in 1988, using purchased grapes and a rented facility. The wine was a success. Drouhin purchased more property, erected a new state-of-the-art winery, and planted more acres. Today a wife and the mother of two small children, Veronique still spends about two months each year in Oregon, overseeing the blending and production of DDO's luscious wines with William J. Hatcher, DDO's general manager.

Left: Winemaker Veronique Drouhin, left, and her mother, Françoise, confer in Domaine Drouhin Oregon's huge tank room. Veronique leaves her home in Beaune, France, approximately two months each year to oversee DDO's harvest and winemaking. Often, other family members or friends come with her to enjoy the Oregon autumns and lend a hand.

JOE DOBBES, JR.
Willamette Valley Vineyards &
Tualatin Vineyards

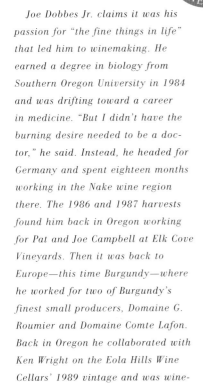

Joe Dobbes Jr. claims it was his passion for "the fine things in life" that led him to winemaking. He earned a degree in biology from Southern Oregon University in 1984 and was drifting toward a career in medicine. "But I didn't have the burning desire needed to be a doctor," he said. Instead, he headed for Germany and spent eighteen months working in the Nake wine region there. The 1986 and 1987 harvests found him back in Oregon working for Pat and Joe Campbell at Elk Cove Vineyards. Then it was back to Europe—this time Burgundy—where he worked for two of Burgundy's finest small producers, Domaine G. Roumier and Domaine Comte Lafon. Back in Oregon he collaborated with Ken Wright on the Eola Hills Wine Cellars' 1989 vintage and was winemaker there in 1990. He worked five vintages at Hinman Vineyards/Silvan Ridge in Eugene and then was hired at Willamette Valley Vineyards in 1996. Willamette Valley Vineyards purchased Tualatin Vineyards in 1997, so Dobbes also oversees winemaking and production for that facility.

mobile communications business that Ed III had managed for a time. In 1990 Ed III, along with his father, Ed King Jr., began development on what is now known as King Estate.

The King family's 550-acre operation near Lorane includes 350 acres of vineyards—the most clonally diverse plantings of Pinot Noir, Pinot Gris, and Chardonnay in North America. Lorane Grapevines, a vine propagation facility operated on the property as a separate business, provides vines that have been grafted to phylloxera-resistant rootstocks for the estate and other vineyards. The state-of-the-art, hundred-thousand-square-foot winery was completed late in 1994, soon after King Estate Winery released its first wines from the 1992 vintage.

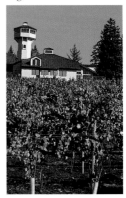

A man with a million-dollar idea, not an actual million dollars, founded Willamette Valley Vineyards. Jim Bernau put together a public stock offering. The offering was successful, and the vineyard and winery, located just south of Salem on Interstate 5, were financed by more than two thousand investors. This enthusiastic crowd also helps at the winery on a volunteer basis. Willamette Valley Vineyards' first wines were made in 1989.

In 1994 Ken Wright, the founder, co-owner, and winemaker at Panther Creek Cellars, decided a change was in order. He sold Panther Creek to Iowans Ron and Linda Kaplan. Wright had also been making wine for Ken and Grace Evenstad, Minnesotans who were enamored by the Oregon wine industry and had founded a small winery they called Domaine Serene. The Evenstads and Wright decided to set up a shared facility in a historic building in downtown Carlton. Today Wright oversees winemaking for Domaine Serene along with his own Ken Wright Cellars, first vintage 1994.

Other small wineries of significance opened, too—Acme Wineworks, Brick House Vineyards, Chehalem

Inset: Willamette Valley Vineyards. *Right:* A young grapevine at Erath Vineyards sends a shoot skyward. When newly planted, grape plants often are surrounded with milk cartons to discourage rabbits and other pests from munching the young plants.

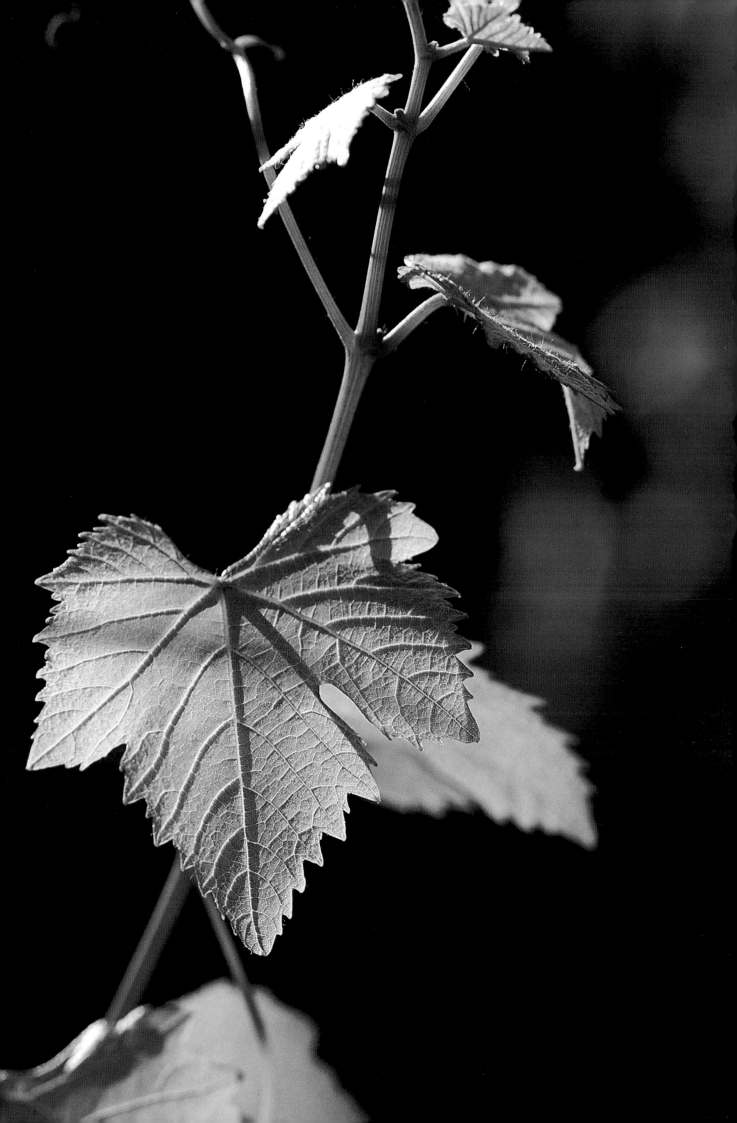

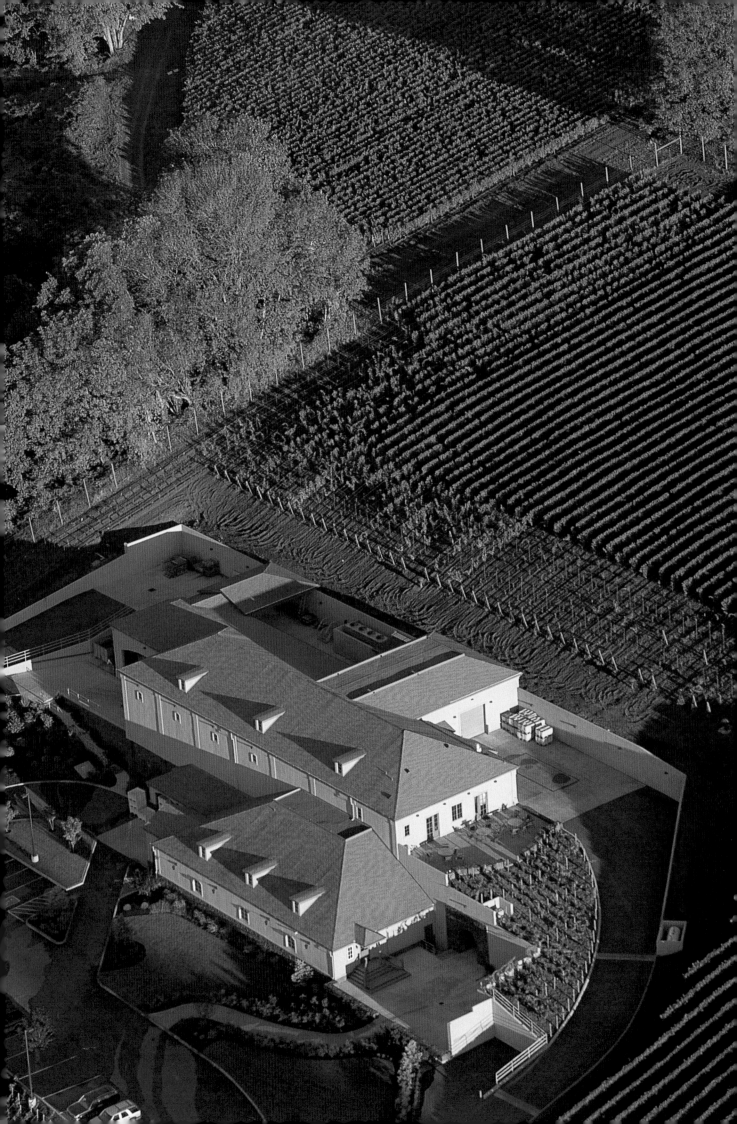

Winery, Torii Mor Winery, Duck Pond Cellars, to name a few. Each brings something special to the industry. Paul and Eileen Gerrie, who were Burgundy lovers from Pennsylvania, purchased an ailing winery in the Eola Hills and renamed it Cristom Vineyards. In 1992 they hired Californian Steve Doerner to make the wines. Since then they have replanted vineyards, revamped the winery facility, and released some wonderful wines.

French-born Bernard LaCroute and his wife Ronni bought a 420-acre property known as the Laughlin Ranch in 1990. The LaCroutes reside in southern California, but Bernard's heart still belongs to his native Burgundy. They found Oregon to their liking and began planting vineyards the following year. The property, now called WillaKenzie Estate, is located near the town of Yamhill in Yamhill County. The LaCroutes hired Frenchman Laurent Montalieu as their winemaker and made their first wines in 1995. Their winery, a huge, state-of-the-art, gravity-flow facility, was completed in 1996.

From California's Napa Valley, Gary Andrus of Pine Ridge fame purchased land in Oregon. Archery Summit Winery produced its first wines in 1993. Located on a steep, terraced site with huge caves built into the hillside, the winery is another breathtaking spectacle employing both form and function. It was completed in 1995.

Two of Oregon's biggest success stories are unique in their own right. First is Firesteed Cellars. No vineyards, no winery, no tasting room. The owner does not even live in Oregon. Firesteed is a brand created by Seattle businessman Howard Rossbach. The concept is simple: make good-quality, competitively priced wine, package it attractively and deliver it to the national market. The market was crying for Pinot Noir, but first-time consumers did not want to take a risk on the high-end stuff. Rossbach met the need by purchasing Pinot Noir grapes, choosing a winemaker already employed at another winery, utilizing an existing facility, and bringing into play his own considerable marketing skills. In less than three vintages, Rossbach created a national brand from what may be the nation's first successful "fighting varietal"

SAM TANNAHILL & GARY ANDRUS
Archery Summit Winery

In 1978 Gary Andrus opened Pine Ridge Winery in the Napa Valley to focus on Cabernet Sauvignon and Chardonnay. In 1993 he made Archery Summit's first wines at the California facility. By 1995 his Oregon winery was near enough completion that wines were made there, and in 1996 the winery was completed. Owner and winemaker Andrus, a former member of the United States Ski Team, became enamored of wine and studied enology at the University of Montpellier in Bordeaux. He sold his interest in Copper Mountain Ski Resort to build Pine Ridge. Assistant winemaker Sam Tannahill's background embodies Pinot Noir. He earned an enology degree at the University of Dijon and worked two years at Domaine de L'Arlot in Burgundy. He also sold wine for Wally's, a prestigious Los Angeles retail store, before moving to Oregon to join the Archery Summit venture.

Archery Summit

Left: Archery Summit Winery, completed in time for the 1995 crush, was built on gravity flow principles, believed by many to allow more gentle handling of the wines. The winery's caves, built into the hillside, do not disturb the view of the winery.

LAURENT MONTALIEU
WillaKenzie Estate

Laurent Montalieu, a native of France, came to the United States in 1987 to work the crush at Domaine Mumm in Napa Valley and improve his English. When Bob and Lelo Kerivan of Bridgeview Vineyards in southern Oregon asked him to be their winemaker, he jumped at the chance. "I liked the work environment in the United States, and this was a great opportunity," he said. After seven successful years at Bridgeview, Montalieu became a partner and winemaker for WillaKenzie Estate, a new venture in Yamhill County that celebrated its first crush in 1995. Although he trained at the Bordeaux Institute of Oenology and worked at Chateau La Tour Blanche near Sauternes before coming to the United States, he has a Burgundian palate and is excited about the cool-climate grape varieties grown in western Oregon.

WILLAKENZIE ESTATE

Pinot Noir. He focuses on consistency in a reasonably priced wine that is drinkable at release.

The other unique "winery" is actually a theme park. Mike and Brian McMenamin started in Portland, restoring neglected buildings that were often of historic value and turning them into brewpubs. They branched into a winery when Edgefield Manor—a dilapidated retirement home located in Troutdale at the mouth of the Columbia Gorge—closed and came on the market in the 1980s. With years of effort and millions of dollars in restoration, the concept became a reality. McMenamins Edgefield is now a complete resort village boasting an on-site winery, micro-brewery, theater, restaurants, gardens, and overnight accommodations. The wines are nice, the ambiance is all Oregon.

There are more stories of Oregon and its wineries. Hundreds of them. But the best way to experience Oregon—the striking landscapes, friendly people, and excellent wines—is to visit. The wine industry hasn't changed *that* much since the early days. It's just fluffed itself up a bit.

RITUALS

Wine is at once a living history and time captured in the bottle—for what better reflects the soft rains, sunshine, and warm earth of any given year?

Wine is ever changing yet ever repeating the same stories. Is the soil of chalk or clay? Often the wine will tell you. What about the growing conditions? Was it a warm year or rainy, or was there a drought? Were the grapes picked before they were completely developed, or did they hang on the vine to full maturity? Taste the wine. It will tell you. Wines are like people. They may be young and sassy, or young but already at their peak; old but graceful and elegant, or weary and faded. Taste the wine and remember the vintage.

With what other beverage can one pop a cork and freeze-frame a moment? The beginning of a romance. A marriage proposal. A wedding or an anniversary. The birth of a child. Graduations. Religious celebrations. Deaths. Rituals, all. And wine is the mystical beverage of ritual.

Right: The antique back bar and tasting bar are focal points in the lively tasting room of WillaKenzie Estate near Carlton. Tasting rooms provide the vital link between Oregon wineries and the consumers of their product. In the smaller wineries, winemakers often are on hand to talk about the wines and their production, or share a special bottle of something not always available to the public.

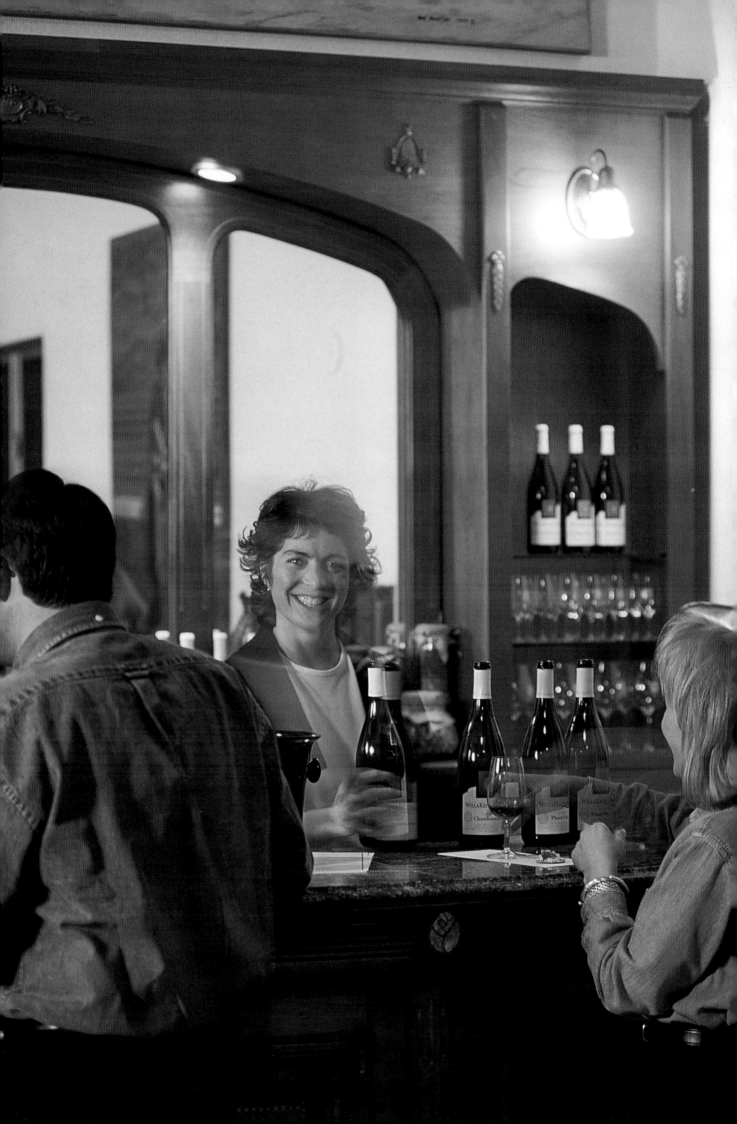

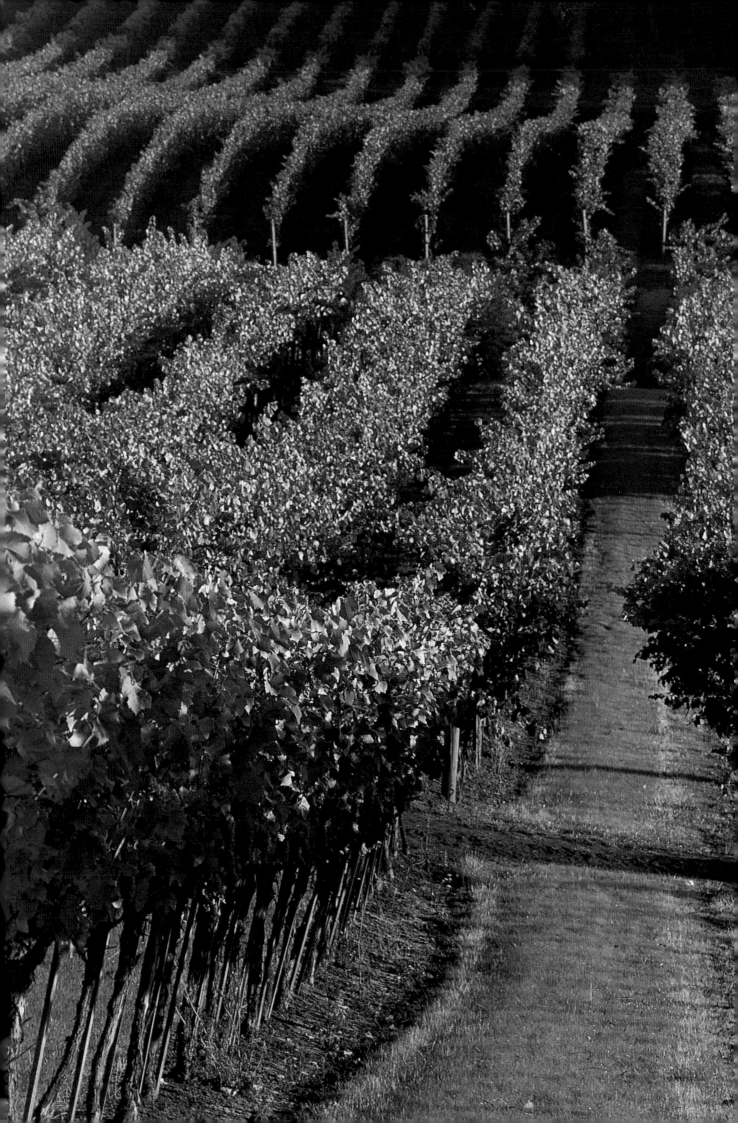

Oregon wine country has its rituals, too. Among the most gratifying are when wineries celebrate rites of passage—The Eyrie Vineyards' twenty-fifth anniversary party in 1995; Erath Vineyards Winery's twenty-fifth birthday in the summer of 1997; Tualatin Vineyards', Sokol Blosser Winery's, and Elk Cove Vineyards' twentieth anniversaries. Only recently have such celebrations been held on a grand scale. It is right and fitting. It is well to celebrate victory over time and past adversity.

There are other festivities as well: a grand opening at Archery Summit Winery or WillaKenzie Estate; a private cellar tasting or an opera bash with New York chefs and Luciano Pavoratti at Rex Hill Vineyards; an oyster and Pinot Gris tasting at Chehalem Winery; an intimate Christmas celebration at Brick House Vineyards.

Rituals on a regional scale abound, too. Foremost in everyone's mind is the Newport Seafood and Wine Festival. Originally created by the Newport Chamber of Commerce to draw tourists to the Oregon coast during the off-season, it has evolved into the state's largest bacchanalian stampede. That is the down side. A wine competition, chef's competition, and other related events contribute to make this, in part at least, a connoisseurs' event that has been mimicked by several other cities on the Oregon coast.

Back in wine country, Thanksgiving and Memorial Day tastings draw the biggest crowds for a number of reasons. These traditional, three-day weekend events coincide most importantly with the wineries' release of their first Pinot Noirs of the previous vintage at Thanksgiving, and their first whites of the previous vintage at Memorial Day. These simple rituals, however, are no longer so simple. Music, art shows, guest chefs, and other attractions draw visitors by the thousands to see Oregon wine country flaunt its stuff.

Inset: Hutch detail at Panther Creek. *Left:* Summer vineyard foliage at Sokol Blosser provides a dramatic contrast to the red Dundee Hills soils. This vineyard, now called Redland, preceded the winery, and was planted as a "hobby" by Bill and Susan Sokol Blosser in the mid-1970s.

JOHN HAW
Sokol Blosser Winery

John Haw's first exposure to wine came when he was in high school in southwestern Michigan. He recalls first driving a tractor and later helping his employer renovate a small cider mill into a winery. In 1983 he decided to try to get to Oregon. "My father's family lived in Oregon," he said. "It's where I belong." Late in 1987, he was hired by winemaker Bob McRitchie as cellar master at Sokol Blosser. Within a short time, McRitchie left Sokol Blosser, and Haw inherited the position of winemaker. Over the years he has grown into the job and has produced some excellent wines, particularly Pinot Noir and Chardonnay. His first love is Pinot Noir. "It's a rascally devil! I love the challenge." And he is intrigued with the opportunity at Sokol Blosser to work toward clonal diversification in the vineyard, which he believes will lead to ever-better quality in the winery.

Two of the biggest and best wine country celebrations focus on Pinot Noir. Since 1987, Oregon Pinot Noir producers have celebrated with their peers from California, Burgundy, and other parts of the globe at an intimate three-day party for six hundred people. The International Pinot Noir Celebration, held yearly at Linfield College in McMinnville, focuses on food, vintages, and Pinot Noir pairings, along with general good cheer. Guests include a melding of producers, wine tradespeople, consumers, and chefs from around the world.

The first weekend of November, Oregon wineries honor their vineyard help with a huge charity auction. Held in Portland, ¡Salud! is a joint venture of the Oregon wine community and Tuality Hospital to raise money to provide free medical services—prenatal care, immunizations, preventive medicine—for nonresident vineyard workers. Proceeds from this barrel auction total several hundred thousand dollars.

But knowing *about* Oregon wine country can't say it all. The best way to experience it is to visit. Spend a day or a week. Curl up in a comfortable country bed-and-breakfast. Enjoy the restaurants of Portland or Ashland or Yamhill County. Taste the indigenous foods—lamb, salmon, shellfish, game, fresh fruit and berries, abundant wild mushrooms—with a local wine. Travel by bus or car or bicycle. Bring your hiking boots. Bring a picnic. Bring a friend.

The countryside beckons. Come along.

Inset: Charity Auction at Atwaters restaurant, *¡Salud! Right:* Brick House Vineyards winemaker-owner Doug Tunnell pumps Pinot Noir into barrels at his tiny winery located on the Chehalem Ridge in Yamhill County. In small wineries such as this one, most of the work is done by hand by the owners themselves—truly a labor of love.

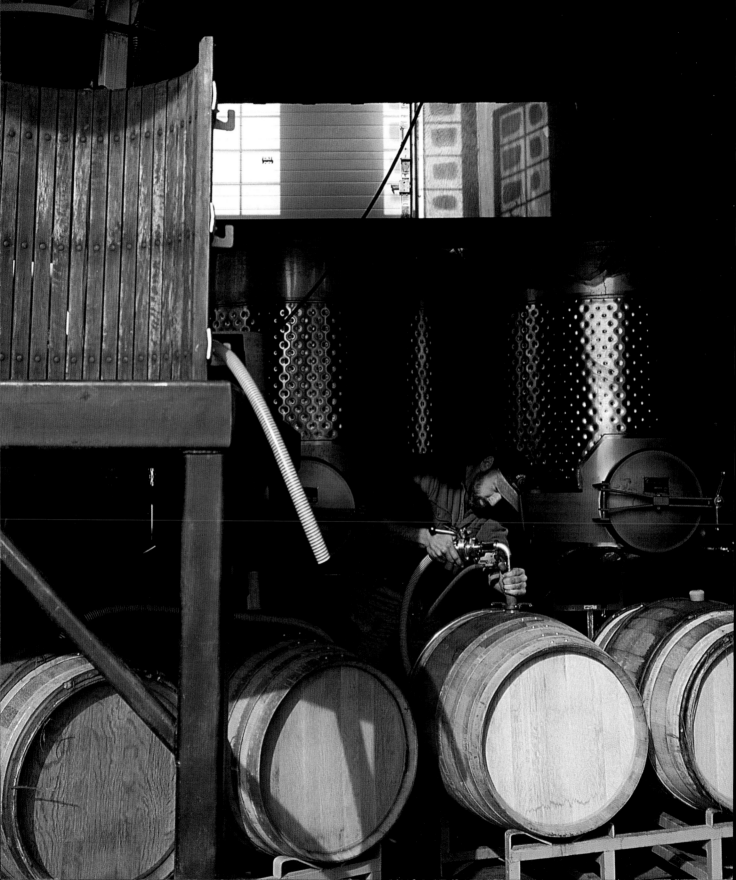

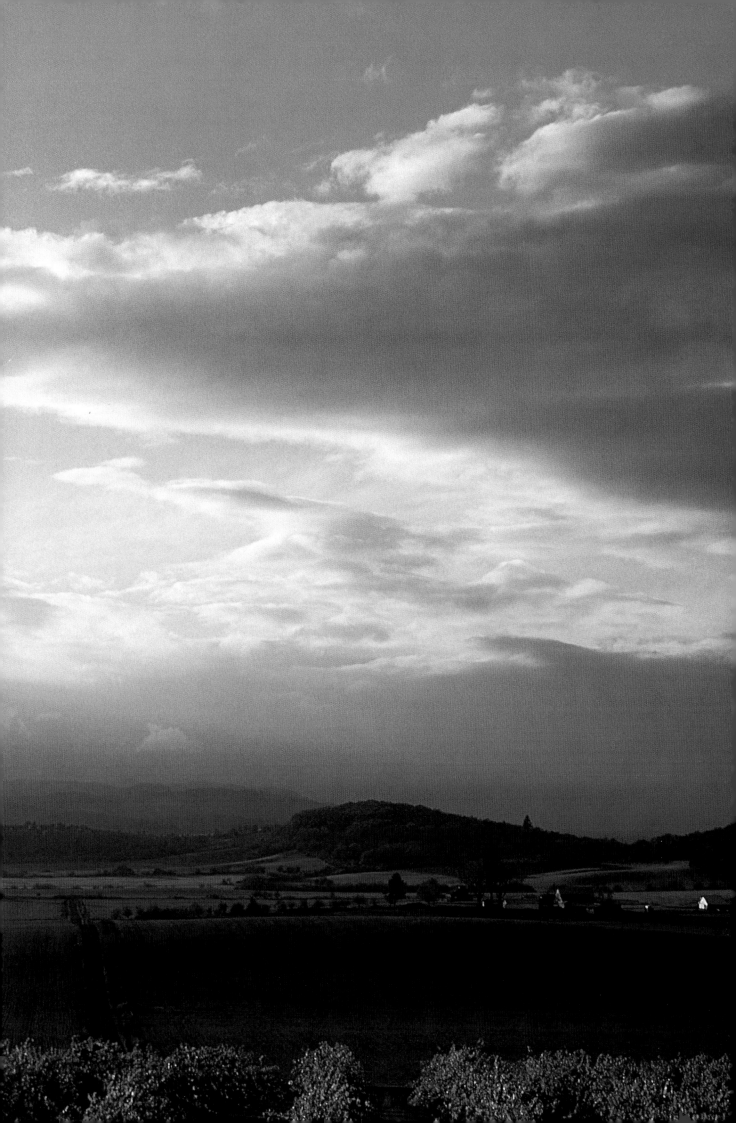

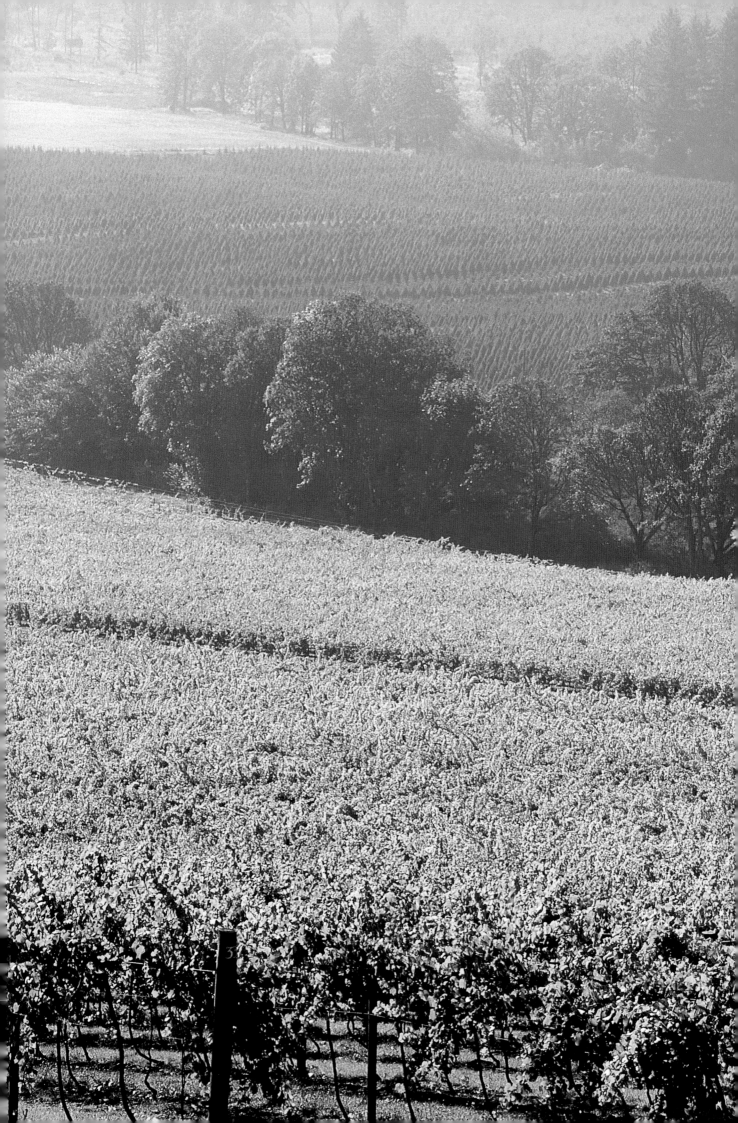

With what other beverage
can one pop a cork and
freeze-frame a moment?

Pages 108 & 109: A dazzling view of the central Willamette Valley and foothills of the Coast Range is seen from Flynn Vineyards near Rickreall. The vineyard and winery are owned by airline pilot Wayne Flynn. *Left:* Willamette Valley Vineyards (shown), a publicly owned corporation based just outside Salem, also owns Tualatin Vineyards in the upper Willamette Valley and O'Connor Vineyard in the Eola Hills. *Above:* A chilled bottle of Argyle Brut sparkling wine awaits a celebratory toast.

Above: Dogs, such as this one at Tyee Vineyards, are indispensible to Oregon vineyards, providing companionship, welcoming smiles, and occasional pest control.